MY LAST WISHES ...

MY LAST WISHES...

A JOURNAL OF

LIFE,

LOVE,

LAUGHS

& A FEW

FINAL NOTES

JOY MEREDITH

wm

WILLIAM MORROW

An Imprint of HarperCollinsPublishers

MY LAST WISHES... Copyright © 2007 by Joy Meredith. All rights reserved. Printed in the United States of America. No part of this book may be used or reproduced in any manner whatsoever without written permission except in the case of brief quotations embodied in critical articles and reviews. For information, address HarperCollins Publishers, 195 Broadway, New York, NY 10007.

HarperCollins books may be purchased for educational, business, or sales promotional use. For information please e-mail the Special Markets Department at SPsales@harpercollins.com.

A hardcover edition of this book was published in 2007 by William Morrow, an imprint of HarperCollins Publishers.

FIRST WILLIAM MORROW PAPERBACK EDITION PUBLISHED 2015.

Designed by Jaime Putorti

Library of Congress Cataloging-in-Publication Data has been applied for.

ISBN 978-0-06-243371-8

15 16 17 18 19 WBC/RRD 10 9 8 7 6 5 4 3 2 1

To my mom, Trish Meredith

CONTENTS

Introduction	n	ix
Chapter 1.	Your Life	1
Chapter 2.	Finish the Unfinished	17
Chapter 3.	What Are You Doing After?	31
Chapter 4.	Where There's a Will	43
Chapter 5.	Medically Speaking	61
Chapter 6.	Going, Going, Gone	77
Chapter 7.	The Service	95
Chapter 8.	Your Stuff	111
Chapter 9.	Need to Know Info	133
Chapter 10.	You Get the Last Word!	153

My Last Wishes For You	165
Resources	167
Books	169
Acknowledgments	171
About the Author	173

INTRODUCTION

omen spend a year planning their wedding, men a whole afternoon choosing their fantasy football picks, and both at least several weeks deciding on a place to call home. That's life! The weird thing is most people spend no time discussing or planning how they want the final part of their lives to go. Think about it: a year planning a party that lasts four hours? Hey, what about a little planning for the ever after that follows?

In My Last Wishes...it's time to start thinking about how you want the final part of your life to play out. If you're asking yourself, But Joy, how do I know if and when this book is for me? Well, if you're over 18, not currently living in your parents' basement (you might have bigger issues that need your attention), have a pulse, your sanity, and possess even one of the following: a set of dishes, a color TV, a car, or a child...then this book is for you!

See, it doesn't matter how far into your future it's going to

happen; we are all going to die (at least according to the latest scientific findings at the time this book was printed). And once we have all the tricky questions answered, we can sit back and enjoy whatever amount of time we have left—whether it's fifty days or fifty years. So instead of hiding from it, let's be strong and view this as a great opportunity to look at our lives, convey love to those we cherish, and celebrate the life we have yet to live.

I myself have lost quite a few loved ones: two of the most important men in my life (including my first love and my great love), all of my grandparents, a high school friend, a sorority sister, a couple of coworkers, and several other friends and relatives. Unfortunately more than one of them had no idea it was going to be their time to go; shocking as it might seem, illness and death can show up at the most unexpected and inconvenient of times. Besides, having attended more than my share of funerals, I often wonder what my own service will be like. Don't pretend you haven't thought about it! We all wonder who will come, who will cry (not that I want people to be devastated, but a tear or two might be touching), or even what our obituaries will say. Why wait? Let's start looking into our lives and take a quick peek at deaths while we can still enjoy the view from a distance.

To make sure we are all on the same page, I want to be clear that this book is *not* a legal document. Rather it's a place to capture your thoughts, a springboard for conversations with loved ones and caregivers, and a planning assistant for when it comes time for your wishes to be honored. Imagine, if your wishes have been laid out clearly, the weight that will be lifted from your loved ones left with the task of following through on your requests. They may not pull it off perfectly, but at least they will have some insight into what you wanted, and a guide to help them make it happen.

Note: This book is written to share information in case you

are dealing with others' end-of-life situations, as well as contemplating your own. So sometimes I refer to you, sometimes to me, and sometimes I'm just talking about the subjects in general. And although it should go without saying, I'm going to say it anyway: Fill out as much or as little in this book as you want. The most important thing is for you to have the conversation with your family and then get as much of it down in writing (hopefully with legal documentation) as possible. If you whiz through the book and cover the basics with your family, you've done more than the majority of the population!

WARNING: Before we begin, know that even though this is a very valuable and practical book, it is also designed (by me) to be humorous (you know, a spoonful of sugar to help the medicine go down?). While I realize not everyone may share my same sense of humor (my sister thinks the odds are about 3:5) my hope is that you'll enjoy it for what it is. And if for some reason you are not amused by something or if it offends you, feel free to scratch it out (I won't mind . . . really).

That said, let me also clarify that I am absolutely not pro-death. I want to be around a long time, and I want my loved ones to be around a long time, too. I mention this because some might find my bluntness and humor to be a little too direct. I've designed it this way, however, with the sincere desire that this book initiates the frank discussion you've always meant to have with your loved ones about your life (including your end of life). I know I would have loved for the people I have loved and lost to have had this discussion with me; it would have saved me a lot of tears and heartache. Luckily for me, I get to honor their memories with this book; and luckily for you, you get to honor your loved ones by using this book while you're still alive and magnificent!

So take a deep breath, and let's have some fun with it.

MY LAST WISHES ...

REPLEATED TO

CHAPTER ONE

YOUR LIFE

hat's life all about? Yeah, I'm not sure either. The better question might be: How's your life going? Before we even get into a discussion about death, let's take a quick look at your life and see if there are some things to be noted there. How many of us have actually taken the time to tell our loved ones all that we want them to know about our lives? Now is your chance.

The following questions will help get you in the frame of mind to start pinpointing who and what is important in your life. First, let's look at the love in your life.

Love

Who do you want to know you love them?
Page 16 17 18 18 18 18 18 18 18 18 18 18 18 18 18
THE PROPERTY OF
Who do you love that you haven't told?
and Andrew Color on the Color of the St. 2016 and 2016 a
alkehajoole gesoones ong us on sweets of
zgyttifa emige dag omder fræmelenn ett kommunektione brugt i sekst d som ende mellen villaming om klose til syttere skalet som eft i ende mel
ndo diodesignico satismum se indottes, no cavorino lim
♥ What would happen if you died today? Have you told the peo
you've listed how much you love them? What are you waiting for Love is the only totally renewable, never depleting resource we c
generate on our own—so stop being stingy. You'll never run out:
A few more love notes:
Who was your first love?
Who is the love that got away?
Who is the love of your life?

2 MY LAST WISHES

Friends

Who are your favorite friends?
and the second of the second o
Who is your oldest friend?
Who is your best friend?
Who is your most trusted friend?
Who is your funniest friend?
Who gives you the best advice?
What was it?
Who are your favorite relatives?
Apply? I sour source to be seen of entries
Who do you miss most that you do not keep in contact with?

What is the nicest thing a friend has ever done for you?
Feeling warm and fuzzy? Good. Let's move on to what you'v learned so far in your life:
Inspirations
Who is the most influential person in your life?
Who has taught you the most?
What was the lesson they shared?
Whom do you admire the most? Why?

	were thought thousantal
	Toppionetpulno al siculal arti-
About you?	defining a feral single and
	the state of the s
- F	
What is the greatest	e lesson you've learned?
What is the greatest	lesson you've learned?
What is the greatest	lesson you've learned?
What is the greatest	lesson you've learned?
What is the greatest	e lesson you've learned?
What is the greatest	elesson you've learned?
What is the greatest	elesson you've learned?
What is the greatest	: lesson you've learned?
What is the greatest	elesson you've learned?
What is the greatest	: lesson you've learned?
What is the greatest	elesson you've learned?

Now let's look at your favorite parts of life:

Favorites

What is your favorite song?	
Who is your favorite performer?	
What are your favorite flowers?	
What is your favorite animal?	1. 1. 16 17 B. 18
Where is your favorite place?	
What is your favorite possession?	
What is your favorite hobby?	
What is your favorite scent?	etorium as comb
What is your favorite season?	
What is your favorite holiday?	and the second of
What is your favorite time of day?	
What is your favorite (lucky) number?	
What is your favorite word?	
What is your favorite color?	and the second second
What is your favorite childhood tradition?	

What is your favorite photo ever taken of you? Describ	se.
What is your favorite feature about your looks?	P P
What has been your favorite job?	
Who has been your favorite boss/mentor?	- N. T
What is your favorite book?	14.5
Movie?	
	1 A 18
TV show?	
What is your favorite game?	

What is your favorite sport?	
What is your favorite quote or saying?	
Zadnovati subi se moleta vernach penagrazuoz et a	
What is your favorite joke?	M
	-1
Abstraction of the state of the	70
What is your favorite spot in your home?	
en region de la compania del compania del compania de la compania del compania de la compania del compania de la compania del c	Ve
What is your favorite restaurant?	
Carl Carlo de La Lagranda Lagranda de decido de la compansión de la compan	
	97
What is your favorite cocktail?	VY

What is your favorite meal?
What is your favorite dessert?
Experiences
What is the funniest thing that has ever happened to you?
Study average or property of the property of t
What is the most adventurous thing you've ever done?
When the second of the second

ou?	s the most embarrassing thing that has ever hap	
	per tu bono. In la speni, nell'ik i il collent i l	
Vhat is	s the most exciting experience you've ever had?	
		9
Vhat h	as been the best day of your life? Describe.	

What is your greatest accomplishment?

If you had to sum it all up in a few sentences:

	The most important thing in life is
A	

Looks like there are some great things going on in your life. The lessons, the laughing, the love . . . Ah, the love! I believe we can never have too much of it flowing, so I'm leaving you with a few parting tips on how to make sure the people in your life feel the love you have for them:

The Thanksgiving Call. Pick one day a year to reach out and thank the people who help make your life great. I like to do it on Thanksgiving (it has the built-in reminder—thanks giving—get it?). Every year on the morning of Thanksgiving I call my closest friends (about 20) and tell them specifically why I am thankful for them that year. My friends say they can't begin Thanksgiving until they receive my call. That warms my giblets! Remember, it's called Thanksgiving for a reason, so if all you're focused on is the football and turkey, you're really missing the gravy boat!

Start a **Birthday Box** for your children. Each year on their birthday add a letter or a short video describing the year you have just had with them and how much you love them. This can be your greatest gift to celebrate and capture the moments of their childhood and heaven forbid . . . it will be an invaluable treasure. (Make sure to include a photo of them or a few minutes of the kiddies on video to make the entry complete.)

Toasted. Who doesn't love to hear how wonderful they are in front of others? Make it a habit to acknowledge people sincerely and publicly. Life is short. Whether in public or in private, tell people often how they make a difference in your life. (Tip: Remember it's not a fabulous idea to give a toast if you're, shall we say . . . toasted.)

Leaf Behind. Most of us know very little about our family tree. Rumor has it that I'm related to Mrs. O'Leary (no relation to the cow) and one of the signers of the Declaration of Independence (oh, to have been able to claim he's the one who came up with that whole *Pursuit of Happiness* line . . .), and yet I can prove neither since there is no good documentation. So leave your heirs a bit of history—even if it's just on a plain sheet of paper. It's priceless!

In the Name of Love. Even our loved ones who aren't here deserve a little love. For example, each year on my grandmothers' birthdays, I honor them by donating blood in their memory (this way their bloodlines truly live on). Be creative. You can do a random act of kindness, give to their favorite charity, or anything else that gives you a warm feeling that you know they would've appreciated.

Is there anything else you'd like to share about your life?

Notes	
Lacuratives in Ather Company on the	<u>y denni 25 sindan cafiba Sael ar</u>
polypolonia annua i polypolonia pro his	
and any men'n usang alam me	
iterorgan ens boden 139 ago z	and seems to the second seems of the second second seems of the second s
ngtour egios en cener sandpenu	sof as if when it is not the server to serve
rikling of the little and a	
along rightantiq at assout ARC	ava ne na zaproje vašt _{era} utilišo. Topo ne stopa vaštir kien managa,
	(P) (1 (C)
A SECURE AND ADDRESS OF THE PROPERTY OF THE PR	<u>ai kit e - cerjed ta tradella a consida, </u>
	7010680

Something to ponder before we move on . . .

Once upon a time I received, as a gift, the book A Short Guide to a Happy Life by Anna Quindlen. The book is true to its word—it was indeed short (50 pages, half of which are pictures) and packed with a simple yet profound message. I highly recommend you pick up a copy of this book, but in case you don't, here's the gist: Get a life. And then, for good measure, appreciate and enjoy the view while you're living it.

I mention this nugget of wisdom here because you are probably in one of two places now that you've finished this chapter. If you're loving your life even more than ever now that you see how great it is in black and white, Yea You! If, on the other hand, you don't love what you've seen in the summary of your life and are feeling a few regrets, then now might be the perfect time to change it. (Otherwise, is there really a point to planning a great end of life?)

Funny this just happens to be the perfect segue into the next chapter. . . .

CHAPTER TWO

FINISH THE UNFINISHED

The unexamined life is not worth living.

—SOCRATES

ocrates . . . so philosophical, that one. I myself wouldn't go that far, but since we're on the topic of looking at your life why not take a look at your whole life? In the previous chapter, we looked at the good, but, alas, we must not forget the bad and the ugly.

The key in life is not that you have no mistakes or regrets (how boring), but instead to "clean" them up as quickly as possible once they're made. I liken it to a festering pus-filled wound—if you don't deal with the ick in your life, it just gets ickier and ickier. (Do I know how to paint a picture or what?)

So let's stop avoiding our mistakes and digressions, and instead determine whether we can free ourselves from them so that there's more room for the love we talked about last chapter. Trust me, you won't regret it.

Regrets

What are your big	gest regrets?		
		Add to be a	
		a state of the season of the	
Car is a district 2.	Green London State Co.		
	A Mark of Suffrage Co.		
			al rank talka
	1 00 1 1 1 1 1 1 1 1 1 1 1 1 1 1 1 1 1		
Section 1997 Section	1. 10 x 1. 10 x 11	080 TH WEST SAID	James Frederic
· A 1 "家,我们,是我们	HEREN ELS HOLLER	\$104 604 375 PT&5	tgatenia i la tipa

What is the worst thing you have ever done? Do you regret it
Would you do it again?
1 1 1 1 1 1 1 1 1 1 1 1 1 1 1 1 1 1 1 1
Oo you have an archenemy? Who? Why?
What has been the worst day of your life? Describe.

nythin	g you need	to confes	s before y	ou die? G	o ahead.	
		4)				
				4 - 5 -	orest of the con-	
					£ 1-1-1-1	
		30 (15) (20) (20) (20) (20) (20) (20) (20) (20			14-1	
		113	19 19	1919/04	(1)9 -2 (1)(1) (1)	k) (
		erice soules		. เราตัวกระที่	9 13 mm () () () () () ()	
What wo	ould you ha	ave done d	ifferently	in life?		
				and the second s		
		eriores este se			endere an	
TEST TO SERVICE SERVIC						100
						- 11

an enter describer of the different	Stranger of	12 15:10
) 	
		- 11
Fear		
What are you most afraid of in life?		
When have you let your fear stop you?		

hat's the scariest thing about being you?		
		APRIL SECTION SOLD AS
	T	
	Forgiveness	
have yo	ou not forgiven? Why? Will you eve	r?
o have yo	ou not forgiven? Why? Will you eve	r?
o have yo	ou not forgiven? Why? Will you eve	r?
o have yo	ou not forgiven? Why? Will you eve	r?
o have yo	ou not forgiven? Why? Will you eve	r?
o have yo	ou not forgiven? Why? Will you eve	r}
o have yo	ou not forgiven? Why? Will you eve	r?
o have yo	ou not forgiven? Why? Will you eve	r?
o have yo	ou not forgiven? Why? Will you eve	r}
o have yo	ou not forgiven? Why? Will you eve	r}
o have yo	ou not forgiven? Why? Will you eve	r?
o have yo	ou not forgiven? Why? Will you eve	r?
o have yo	ou not forgiven? Why? Will you eve	r?
o have yo	ou not forgiven? Why? Will you eve	r?
o have yo	ou not forgiven? Why? Will you eve	r?
have yo	ou not forgiven? Why? Will you eve	r}
o have yo	ou not forgiven? Why? Will you eve	r?
o have yo	ou not forgiven? Why? Will you eve	r?

'hy?	
	Silvan tropinavnih sultinska i s Sulani
,	
	ne 12 de nome en
	Constitution of the consti
there anyth	hing that can be done to rectify these regrets and
udges?	

Awaiting

Much unhappiness has come into the world because	
of things left unsaid	
—Dostoevsky	
the father is a branch as or all and a substitute and a decided	
What will you regret in your life if you don't do or say it?	

_	
	a disa na agregación forta seal desemble no entreno, estant deste e
	a na starte na sale a sakulti transa 1515 ili saladik ma
	e yezhetuen zun arfretten besarezen a bebak

Relationships

Whew! The regrets, the apologies, the confessions—it's all a little unnerving to think about, huh? Well, the good news is the chances of you dying today are probably pretty remote, so you still have time to clean these things up. Most people put off dealing with their regrets and hope they'll just go away, but even if they're not at the forefront of your thinking, they still haunt your subconscious (yes, I've spent years in therapy so you won't have to). Trust me, it's much better to suck it up and make it a top priority than to drag baggage around with you for even one more day. When I did this myself, it was such a load off I actually lost weight. No kidding. So if you are contemplating dieting, think about getting the monkeys off your back first.

How, you ask? Simple. Map out your life on a big sketchpad of paper; include all the different aspects: family, friends, loves, work, community, etc. Pay special attention to the areas and relationships that are negative or unfinished. Now all you need to do is take responsibility (even if you're sure it's only .9999% your fault) and clean them up! To aid you, here are my top tips for a fester-free life:

- 1. Go First. Let's face it, many of our stupid fights go way too far because no one will take that first step to talk it out. Just do it. Pick up the phone, write a letter, arrange a visit, and then apologize and own *your* part in the madness. Really, in the end, who cares who's right or wrong? Keep in mind you can't make others take responsibility for their part; all you can do is own yours. Besides, it's not for their sake; it's for your own peace of mind. Once your amends are made, there is no rule that you need to stay in a relationship after the fact. When it comes down to it, life is way too short to have any conflicts left hanging or ill will floating out in the world. Good karma does work; if you clean up your messes, there's no stopping great things from flowing into your life.
- 2. Don't Mess with the Crazies! Even though you should always take responsibility for your own part in any broken relationship (see #1), that doesn't mean you should try to reason with people who are off-kilter (read: sociopaths, narcissists, and the like). Get in, apologize, and get out! Don't think you can stay in a healthy relationship with these types of people—they are not capable of it and will just end up hurting you in the long run.

Believe me, the narcissists who were once in my life are so vain they probably think this tip is about them (don't you, don't you?). Sadly, the thing I've found with people who only think about themselves is, well . . . they only think about themselves! That's why it won't even occur

to them to apologize to you, and why it's a waste of time for you to wait for them to. The healthier thing to do is to tell them you hope they find happiness in the world and wish them well (after all, you can't help who you love, only who you choose to spend your time with and energy on). Say a little prayer that they move out of state for good measure . . . and then just let it go. Otherwise you'll end up making yourself crazy.

3. Take a Walk. We can never really imagine what it's like to be in someone else's shoes, living with their particular life circumstances. I mean, is it possible to ever truly know what's going on with another person? One of my favorite songs, "What It's Like" by Everlast, tells several stories that place you in the chaos people struggle with in their everyday lives. It's so profound to really grasp that we have no idea how muddled a person's life is unless we try, as the song suggests, to "walk a mile in his shoes."

The fact is we will never know why people do certain things. Most of the time people hide their wounds, so even if you think you know, most likely you have no clue. With the mind being so unfathomably complex, chances are that not only are you not going to be able to figure everyone out, but others might not even be aware themselves of their own true reasoning. Let's face it, we all respond and react differently depending on a multitude of reasons. That's why, as adults, it's our choice to stay in someone else's life . . . or not. So, either cut people in your life some slack and show some compassion and understanding, or if you can't take a

walk in their shoes, maybe you should do them a favor and take a hike.

If you need any further motivation to "clean up" your relationships, think about it this way: If either of you were to die today without resolving or clearing up an issue, would you really want it following you around for eternity? All righty then, stop the festering in your life by going first . . . today!

Stuff

Now that we've tackled your relationships, let's take a look at the non-human annoyances in your life: your stuff. See, sometimes objects can get in the way as much as your emotional baggage, so now it's time to focus on your literal baggage. It just so happens there is a pretty easy way to get rid of *things*, too. Either give it away, throw it away, recycle it, pay someone to take care of it for you, or burn it. Come on, do we really have the time and energy to fester over non-living things? I say no!

Now people who fight over money, a failed business, or family treasures might have a slightly different perspective on this (a certain object, heirloom, or entity might be too precious to part with in your mind). My point, however, is that festering does you no good in life. The majority of the time, it's easier to just let go of these things. But, if a dispute involves something you are really determined to be right about, don't stew about it—take action. Go find an intermediary, a great therapist, counsel from your clergy, or a reputable lawyer and get it handled, because the only person who is likely to suffer from your festering is you.

Dreams

Lastly, regarding the adventures and experiences unfulfilled in your life, what are you waiting for? Since we have no idea exactly how long we will be here, the least you owe yourself is to try to make your life as regret-free as possible. If your dream is of having a family and you're fertilely challenged, adopt or become a foster parent. If your dream is to open a business, get a business plan together and start working in that field. If your dream is to visit Paris, get some brochures, open a vacation account, and set yourself a deadline of a year to make it happen. The problem with only having dreams in your head is they don't come to life in there all by themselves. Dream on paper and with workable plans instead.

And along the way, keep reminding yourself that the only failure in life is not pursuing our dreams. This doesn't necessarily mean selling everything and moving to Belize (or maybe it does!), but whether your dreams are big or small, try to open up your life to the pursuit of them.

Notes		
	energy of the same	en e
Property States I will be	STATE OF THE SECRETARY	whitegor as a
Tiple margers, other configuration	<u>- 19 - 19 - 19 - 19 - 19 - 19 - 19 - 19</u>	
	Their aut areas	h 1991. 277
		1 2 20
THE COURT OF STREET	en Samuel de Marie	Electric Control of the Control of t
	NEW YORK OF STREET	nsk illigari ca.s
And Colored Lot 1 Tan		
		1 3

Is there anything else you would regret not noting before finishing

CHAPTER THREE

WHAT ARE YOU DOING AFTER?

ou know how they say "what doesn't kill you makes you stronger"? Well, how about for this chapter we let it kill us (don't worry we're only going to pretend we're deada little 'possum play for the fun of it!). Now I'm not one of those people who thinks about death obsessively, but if you are, maybe you should skip ahead to Chapter 4 or even set down the book for a while (I don't want to encourage your fixation). For the rest of us . . . heaven, hell, worm feed, reincarnation as one of Oprah's pampered pooches? Let's face it, we all have guesses and hopes about where we go when we die, but since no one knows for an absolute certainty it might be fun to ponder the possibilities. Funny thing is whenever I stop to think about what happens after our time here on earth, I often appreciate the life I'm living today even more than ever before. So really you could say discussing death can indeed make you stronger (huh . . . I guess they were right after all).

	hink happens when you die?
	A TANKET STINKERS TO
	10 Y 1 1 A 17 7 1 1 1 1 1 1 1 1 1 1 1 1 1 1
	SUFFIX DIVIDED
Are you afraid	to die? [N] [Y]
	ot?
	the proposition for the larger shoots with the
	pit med vijaviška regulas i si suarok i siderija dogodo. Diska mentamik en mak od o ca beskija godogodo sida i sida i
	Na we spilicon and new yet I have
atir jeni _a i voje Samo samo s	agir may , way ya wang wat nayyen sami agir
ndr den ji sa di Serial kasasi Ulik sa dalah	o et de elle balega, hade jeug propos, representa selle operationed modernal Laure des jeugs des chies
ada den jorda Salada kalenda Din salada da Salada anda da	agrama, soo a waxaya, hale waxa waxa, agaa agaa
ods prej or s Solvens Legal Solvens co Walkers	agon may page of the property of the second second of the
oda wei, own books a kypi book 2 to en that on the end and of ac-	e in heaven? [N] [Y]
ada yeri, Taras Lina sa 2248 Sanif Lina ca Tilishan Tara	e in heaven? [N] [Y]

		effection, or,	1 3 870
	1-1-		$M \subseteq M \subseteq M$
		100 - 100 S	
Who will be there to meet y	ou at heaven	's gate?	
And the second second second second			14 N. 15
	4 4 4 4 8	S 6 1 1 1 1 1 1 1 1 1 1 1 1 1 1 1 1 1 1	
TO STATE OF THE THE STATE OF TH	an an Appeter see		
		al.	
What is the first thing you'l	l say to/ask C	God?	
			- 11

Vhat's it like?	
, mic 3 ic like.	
Page 1	on and the state of the state of
Oo you think there is a devil?	[N] [Y]
Does he have a tail, horns, weagg? Describe.	r red, make a mean hard-boiled
Oo you know anyone who mig	ht be waiting down there?
Which place are you figuring yo	ou'll end up? Why?
1 /	

The shade are our walls, where a subscribe world
Visit and the second of the se
Do you believe in reincarnation? [N] [Y]
Who would you like to come back as?
Were you already here? [N] [Y]
Who were you?
Do you believe in being able to revisit the living? $[N]$
What sign would you send to your loved ones?
The Albert Hills of the Albert Hills of the English Control of the Albert Hills of the

Whose gu	ardian angel v	would you	i come ba	ck as?	
Who would	d you haunt?	What wou	ıld you do	>}	
					der of
Have you e	ver felt visited	l by some	one who l	nas passed?	The Act
Describe.					Special Specia
Selfe a				od in ma	
What or wl	no would you	be willin	g to die fo	or?	

What is the worst way to go?	
	Y
What is the best way?	
and the second of the second o	
	N E COMPANION DE
Have you ever come close to death? [N] [Y]	
Describe.	
Describe.	
	1 - 1 - 1 - 1 - 1 - 1 - 1 - 1 - 1 - 1 -
	11 - F.A.
rc 11 - 11 - 1 - 1 - 1 - 1 - 1 - 1 -	1121
If you could predict a good age for your death, what we	ould it be?

	<i>a</i> .
	tion in the barryon. The property
Who will you miss most?	
Describe your ideal last day	nation is seen as a seen of the seen
eserios your resur last day	

La Certara resco selegar con alla loca di una si si all'eletano aggiorità reggiorna di una di una con esta considera aggiorna di una con esta con e

A Little Obsessive?

As I said in the beginning of the chapter, even as the author of this book, most of the time my life doesn't revolve around thinking about death. As a matter of fact, I don't really understand people whose lives do (funeral/end-of-life professionals excluded, of course). Shouldn't our biggest fear be not living our lives to the fullest? Isn't that scary enough? I figure . . .

If you believe you're going to heaven, what is there to be afraid of? It sounds like a fabulous place to end up, thus the name—HEAVEN. Really, what could be better? Might as well enjoy your time here, before you, well . . . enjoy your time there.

If, on the other hand, you believe you're going to hell (and you're at all concerned about it), don't you have amends to be making immediately? I mean, do you really have the time to just sit around waiting for the fire and brimstone? Plus, if you are truly worried about it, doesn't that imply you have a strong conscience; therefore, how bad of a person could you really be? (Not sounding very hell-worthy if you ask me.) And if you don't have a conscience, you're probably *not* worried about anything (let alone reading this book), and then doesn't it seem odds are about right that you should end up hell-bound?

Or maybe you believe you get another go-around or

two . . . boy, that sounds exciting! Just hang in there and eventually you should have a really cool life (or maybe even several). I mean, talk about do-overs, how bad can it be if you know you can just keep adjusting what isn't working in your soul until you reach nirvana?

And lastly, if you believe you just die, shouldn't you be dreadfree about it all since there is no stopping death and there's no afterlife to worry about anyway? Isn't your whole life just a gift? Shouldn't you just be happy that you control your destiny and only today matters? Besides, isn't it refreshing to think you can be a really great person just because you want to be, not because you're worried that someone's watching over you all the time?

In a Little Denial?

Then there is the polar opposite, denial of death. The thing about avoiding death and the ensuing discussion is that it doesn't honor the people we have already lost. When we lose someone close to us we certainly don't want to be reminded of it constantly, but by avoiding death as a part of life, we leave the ones we've loved and lost out of our everyday lives. I know when I'm gone (even from the room), I would like for people to continue to include me in their lives, and laugh, and remember the love we shared and the times we had together.

Plus, do you seriously believe if you don't think about or discuss death you'll escape it? Do you know anyone who has? The one stipulation for riding this roller coaster we call life is that eventually we all need to get off and let someone else have a go. You'll find, while you're enjoying your trip around the tracks, that fully living and loving life includes discussing death (and as you'll see in the next chapter, sometimes it even includes writing about it).

A Little Joy . . .

By now it be should clear that I'm mostly all about the questions; no answers to "the world beyond" here. Therefore, if you're still mulling over the mysteries of life and death, it would be wise to consult the clergy, philosopher, educator, or Yoda of your choice. My only insight is that sometimes I find it's along the *journey* to discovering the answers where the wisdom and fun exists. Happy trails!

Notes

Any other thoughts you're dying to share?

CHAPTER FOUR

WHERE THERE'S A WILL...

... there's usually a lawyer. Since a couple of my close friends are lawyers (not to mention I don't want to be sued for libel), I've chosen to skip the anticipated lawyer jokes in this opening statement. Instead, I'll just say that paperwork is a bite! It does, however, make things a heck of a lot easier when something needs to get done. So in that vein, let's focus on the fact that there are basic documents you must get handled, all of which will be spelled out in this chapter. Remember this book is not a legal document, nor am I a lawyer (or even pretend to play one). The object of this chapter is to prompt you to think about this topic and to encourage a dialogue. There is no way that I could cover all there is to know about these topics; plus, laws and regulations vary widely from state to state (that means don't come crying to me if you didn't get the right thing notarized, or if your trust is untrustworthy).

Also, try not to be too awed when I use an impressive term like "estate planning." An estate consists of anything that a person owns. (You own a set of dishes? Congrats, you have an estate

to be designated once you're gone!) The point is, there is no need to be the Great Gatsby to have a few things written out. In Chapter 8 we'll get into your thoughts about who gets what; this chapter is only to spell out what the documents are and how to get them squared away. Therefore, this chapter is mostly an overview, and in the next four chapters we'll get into specifics.

Medical Documents

Advance Medical Directives are documents specifying what you'd like done during serious illness, incapacity, or near end of life. You still make your own decisions as long as you are capable of deciding for yourself, but once your doctor declares you are incapable of making decisions, your AMD goes into effect. The three documents that make up your AMDs are a Living Will, Medical Power of Attorney, and a Do-Not-Resuscitate Order. Below we'll cover the basics, a few tips you should be aware of, and how to go about putting them in writing.

Living Will

A living will is a document used to spell out your wishes when you are unable to communicate in regards to medical treatment (especially life support). It can cover medical treatment received or refused, treatment for pain, and organ donation.

TIPS

Life support differs widely from state to state, so it's important to spell out specifically what *you* consider life support to be (you can begin to do this in Chapter 5).

Draw up a living will as soon as you're an adult and want to make decisions for yourself. Don't wait until you are 88 to fill one out, since it literally only takes minutes to complete (see Medical Power of Attorney for an alternative).

Make sure your doctor or other health care provider puts a copy of your living will in your medical files.

Living wills are not flawless. If they cannot be found in your paperwork, if your children fight over them, or on the rare occasion your doctor will not honor them, they will at least give some direction to your proxy (see below) who can fight to have your wishes honored.

• Heads Up: Living wills have been tainted a bit with politics in that they don't always say what they imply. Simply, this means not all states consider medication and sustenance (meaning food or a feeding tube) to be included in the term "life support." Either way you sway, make sure you thoroughly read what you are signing. And if you feel the need to be more specific than the basic form outlines, you can add your own instructions as long as they follow the guidelines of the original living will.

Medical Power of Attorney

A Medical Power of Attorney (also referred to as Durable Power of Attorney for Health Care or Health Care Proxy) gives someone the authority to make medical decisions for you when you are unable to make them for yourself. For our discussion, let's call that person your proxy (it has a nice ring to it). Your proxy should be at least 18 and of "sound mind" (and so should you when choosing one). It's important to feel comfortable that your proxy knows and is willing to carry out your wishes. Although you can limit their power by specifying what scope they have, a proxy's most crucial function is to deal with the circumstances as they present themselves. Since you won't be able to anticipate every condition that might occur, it is often better to give them the wiggle room to handle things as they come up. The most important thing is to choose someone you can trust and then explain your philosophy as clearly as possible to them.

Lawyers are going to encourage this form over and instead of a living will, the reason being that living wills sometimes are too vague or too restrictive. If you feel comfortable that your proxy understands, is willing to carry out, and will be available for the task of carrying out your wishes, this might be the only form you have. Or you can go for a combo form that includes and pretty directly spells out your choices, like the *Five Wishes* booklet (see Resources).

TIPS

A word about witnesses: Most witnesses to the signing of this or any other legal document need to be at least 18, of "sound mind," and cannot benefit from your demise. Usually excluded: family members, other inheritors, your health care provider, anyone related to a hospital, nursing home, etc.

An alternate should be named in case your choice of proxy is not able or willing to take on the obligation at the time when it is needed.

Your Power of Attorney for financial matters can be different and separate from your proxy for health care.

Your proxy should be someone who can stand up for you and make the tough decisions. Also, someone you trust to follow through with your wishes. (Make sure you have a proxy with moxie!)

As with all legal documents, if you decide to change your proxy, retrieve all previous copies of your Medical Power of Attorney and destroy them.

Make sure your proxy has a copy of your signed Medical Power of Attorney document.

Guilt, Oy Vey! You might also want to have the conversation with your proxy reassuring him that he is not responsible for your death and you don't consider any decision he makes anything more than him honoring your wishes. And a big pre-thank-you is a nice touch!

WHO?

Who would you like as your proxy? _	
in the state of the state of the state of	
As your alternate?	

(You must now ask them and, at the end of the chapter, note when you had the conversation and provided them with copies of your Medical Power of Attorney documents.)

Warning: If you do not appoint a proxy, then each state has its own laws governing the hierarchy of who makes medical decisions in the event a patient lacks decision-making capacity—this assigned person is designated your *Health Care Surrogate*. For adults the order usually goes something like: spouse, adult children, parents, siblings, other relatives, close friends, etc. Unless a marriage is officially over, an evil spouse can trump a loyal kid—or an evil kid can trump a loyal partner (if not married) . . . or if you have no spouse, children, or siblings, it could come down to your wacky cousin Ralph.

GETTING IT DONE

A Living Will and Medical Power of Attorney are two of the most popular and easily accessible documents to fill out.

- There are several great websites and organizations that help with information and provide these forms for free or a small fee. Try:
 - National Hospice and Palliative Care Organization; www.nhpco.org or www.caringinfo.org; 800-658-8898. Provided for free.
 - Aging with Dignity; www.agingwithdignity.org; 888-594-7437 for the *Five Wishes* document. Small fee, but worth it. Currently legal in 42 states (check for yours).
- A basic form is found at most hospitals, hospices, nursing homes, or through your attorney.
- You can check with your state's department on aging or department of public health where they can be downloaded.

DNR

A Do-Not-Resuscitate order is a physician written and signed order, requested by the patient, to instruct health care providers not to attempt CPR (cardiopulmonary resuscitation).

TIPS

Make sure you inform your family of these wishes. You don't want them standing there yelling at the doctors for not doing anything.

Emergency medical technicians cannot necessarily be expected to honor DNRs. (Calling an ambulance implies you want them to help you and that is what they will attempt to do. Same goes for a trip to the Emergency Room.)

GETTING IT DONE

Your personal physician issues a DNR to be placed in your file, but each time you get admitted to a hospital they will ask you to fill out a new one so they have it with your admittance information.

Note: The ABA (American Bar Association) suggests that you re-examine your health care wishes in case of any of the "Five D's":

Decade-In every new decade.

Death—In case there is a death close to you.

Divorce—When there is a change in marital status.

Diagnosis—If your health becomes an issue.

Decline—Either in health or your ability to live independently.

Estate Documents

Will

A will is a document that indicates how you want your estate distributed once you die. It also allows you to nominate a guardian for your children when you're gone (more in Chapter 8).

Why do you need one? Simply, because if you don't leave a will then the state decides who gets what. I think we can all agree that you can do better than the state at deciding who should get your moola and your children. You absolutely need one if you have a child with a disability or if you are part of a domestic partner relationship (the law in most states does not provide much in the way of protection for your family). Actually, we all absolutely need one, so let's all just jump on this bandwagon, shall we?

You must be 18 years of age and of "sound mind" to create a will. You have to state that it is your will, and then date and sign it in front of at least two (three in a few states) witnesses. Rarely does a state require a will to be notarized, but it's best to check with your state's rules or just be safe by having it witnessed by three over-18, non-inheriting people who seem sane enough to withstand scrutiny, while a notary is present. (Note: The witnesses do not read your will, they are just witnessing that it is your will and you are of sound mind when you sign it.)

A couple quick details . . . you'll have to name an executor

(person who is designated to carry out your wishes) to your will and also at least one alternate in case the original is not able or willing to serve. Beneficiaries are the ones (person or organizations) who you name to get your goodies when you're gone. Once you die your will goes into a court procedure called probate. This basically means that a state court ensures that your will—or if no will, the state laws—are followed in regard to your estate. (Probate takes time, usually up to six months or more. Records are open to the public.)

TIPS IN THE STATE OF THE STATE

See a lawyer if any of the following apply to you: your estate is worth \$1 million or more (might be tax issues); you own a business; you are responsible for someone who is disabled; you fear someone might contest the will (especially a spouse or child); you are in a complicated family situation; or if it would make you feel better to do so (I find some lawyers a delight to spend time with). Really, it's best to see a lawyer under most circumstances, but absolutely see one if any of the above applies to you.

Make sure your executor (and the "runner up") is willing and able to serve. This is not something that you want to spring on them once you've gone.

Type the will out or use a computer program (handwritten wills are not valid in some states). Besides, you think you have neat handwriting, but your loved ones would like to be clear whether you're leaving them the car or the cat.

Community property laws rule in some states. So don't give away everything until you check what your spouse is entitled to legally (I hope you like them enough that you were planning on leaving them a good amount of your stuff. Otherwise may I suggest a lawyer for another reason . . . oops, I digress, that's a whole other book!). Same goes with prenuptial agreements and business partnerships.

You are under no obligation to be fair or even include *adult* children in your will. If you wish to disinherit a child it must be specifically stated (or they might contest it). Although not legally required, you might also want to state why.

When updating your will, not only should you destroy any and all previous copies, but you should also state this is your current will and any previous wills are revoked.

Upon divorce, immediately ensure that not only your will is reviewed, but also any accounts that list your former spouse as your beneficiary. This also applies in the case of good news, such as the addition of a child.

With your possessions, it's a good idea to add something to the effect of "if owned by me at the time of my death" so there is no fuss in case you leave something that is later sold or broken, etc.

Grandparents might want to include a line referring to "any future grandchildren" if they intend to leave all their grandchildren a gift (especially monetary).

BASIC VOCABULARY

Estate: everything you own.

Testate: dying with a will.

Intestate: dying without a will.

Joint Tenants: when two or more people own an asset. The share of the first to die shifts to the surviving owner.

Per Stirpes: Latin term that specifies that you want your grandchildren to inherit their parent's portion if, tragically, your child passes before you.

Codicil: an amendment to a previous will. Since it is not advised that any additions or adjustments be made to the original will, this allows you to tack on additional information as long as it refers to the original will and the same formalities of the original will are followed.

GETTING IT DONE

There are software programs that are relatively inexpensive and walk you through this process (many lawyers use similar ones when you hire them).

A few books, as well as some legal sites, cover necessary forms—just make sure they're legal in your state.

And there is always the good old-fashioned method of typing one out yourself, which if you follow the basic tips, is better than nothing.

Living Trust

A trust is a document (agreement) that "holds" your property for the benefit of another (beneficiary), either during your lifetime (living trust) or after death. Basically, you transfer the title of your assets to a trust, and when you die your beneficiaries inherit the items in the trust as you have specified.

The trustor (you) creates the trust and owns the property that has been put in it. The trustee is the person who controls the assets in the trust (usually you until you die or become incapacitated). The successor trustee is the person who succeeds the original trustee when they can no longer serve as trustee. The successor trustee then turns the trust property over to the trust beneficiaries (family, friends, charities who inherit what's in the trust) and handles any other tasks spelled out in the trust. With a trust, beneficiaries are able to inherit without having to go through the public and possibly lengthy probate process.

TIPS

Property that can be included in a trust: homes, other real estate, vehicles, stock, bonds, investment accounts and bank accounts, etc.

You still need a will even if you have a trust. The will is needed to issue a guardian for your children and to designate an executor to disperse whatever items are not put into the trust.

There are often scams (especially on the Internet or through direct marketing) that claim you can get unrealistic tax advantages by setting up a trust. Remember, if it sounds too good to be true, it not only usually is but often can be illegal. Don't be fooled by claims of foreign trusts or pure trust organizations: Most are bogus (some are legitimate, but would involve only reputable lawyers

and very specific situations). Your best bet is if it doesn't directly involve a reputable lawyer who is accountable to the state bar association, don't do it.

GETTING IT DONE

There are a few books and software programs that cover trusts, but since oftentimes people are using trusts for more intricate and financially sensitive reasons, it is best to work with a lawyer when forming one. And the more complicated your situation, the more you want to look for a highly respected lawyer who specializes in this area. (I would not suggest Big Jim's Property, Litigation, Estate Planning, and Bait & Tackle for his expertise.)

Power of Attorney

Power of Attorney is a document that allows someone to act on your behalf. A standard (Nondurable) Power of Attorney is in effect when you are still able to manage your affairs, but need your POA to act for you in certain situations (i.e., you are out of the country, for banking purposes, etc.). You can specify the parameters and have different POAs for different situations. It is no longer in effect if you become incapacitated.

A Durable Power of Attorney differs in that it stays in effect when you are incapacitated. It gives your POA the ability to act on your behalf to conduct any affairs you would normally take care of yourself. (Your Medical Power of Attorney is a durable POA.)

TIPS

You can have more than one POA designated for specific duties: Financial Power of Attorney, Medical Power of Attorney, etc.

POA's power ends upon your death. Your executor or successor trustee now handles your affairs. (Reminder: The POA and executor or successor are sometimes the same person.)

Since these are powerful documents, make sure you completely understand the power you are granting someone to act on your behalf.

Not to be alarmist, but if you don't have someone you would trust absolutely, don't have a POA. There are horrible stories of people being robbed by others they thought they could trust. (This is especially true of the elderly.)

GETTING IT DONE

Institutions (banks, financial facilities, etc.) often have POA (or POA-type) forms. Otherwise, there are forms that can be found online and printed. I recommend working with an attorney if you're not familiar with the POA process since they can explain the parameters and any specifics that you want used.

GENERAL TIPS

If you plan to work with a lawyer for any of the above documents, it's a great idea to spend some time coming up with a list of questions, as well as deciding on

the key issues, before meeting with them. Not only will it save you time and money, but it makes it easier for the lawyer to ensure all your concerns are handled.

If you'd like to write your own will or trust, be forewarned that it'll be hard to find a lawver to look it over. They won't want to take on the liability of ensuring someone else's work, and they'll have no idea if you've included all the relevant information. So if you have a lawyer or can afford one, use one; if not, a Medical Power of Attorney and a will are the two documents you should draw up. It's possible for you to get them both done relatively simply and at a minimum cost.

Note: If you are the one serving as an executor of an estate, make sure to document what you've done and get signed receipts indicating a beneficiary has received an item.

Money Matters

Life insurance and disability insurance are topics that need your attention. It's a good idea to speak with an insurance agent, accountant, and/or financial planner to help ensure that these issues are covered.

Living Will				
Medical Power of A	ttownav			

Will	as the 2018 A Com-	
Living Trust	Carrier and Commenced a	
Additional Powers o	f Attorney	
	big that will	
Other	ANTENIA CHE STATES	The violation
WHO HAS COPIES O	F YOUR LEGAL DOCU	MENTS? DATE RECEIVED
Will	Julie Martin	
	after discussion of wishe	
notes		
notes		
notes		

notes

notes

notes

notes

notes

DOCUMENT	WHO HAS COPY	DATE RECEIVED
notes		· Smith
notes		The state of the s
notes		
notes		
notes		
notes		<u> </u>
		
notes		
notes		
noces		
notes		
notes		
notes		
Acres Contracts and State Contracts	AND LONG OF THE CHARLES THE REST OF THE PARTY.	

It can be helpful to number your copies and list reference numbers above. This allows you to keep track of who has what and which copy is missing if you decide to retrieve them and write a new edition.

Anything e	else you	trust	loved	ones t	o know	and	are	willing	to
share?									
Notes									
110003									
					* ** ********************************				
South and the same				122		A STATE OF THE STA		electronic	
					9/2100			1 1 1 1 1 1 1 1 1 1 1 1 1 1 1 1 1 1 1	
					open (18)				
(a) (b) (c) (c) (c) (d) (d) (d)		e 8 V							
	4.275(4.			ra de la final		715		- 50	
							2003 i		
white the same					Allen a				
					and the second second				
		1,000			Sec. 25. 1				
Section (Control of Control of Co					•				
		10							
					energia escribi				
		4.3				Lagran		dia mai	

CHAPTER FIVE

MEDICALLY SPEAKING

ow that I've eased you into this section with a little humor—brace yourself—because I'm about to be profound. Well, not actually me, but Holocaust survivor Viktor Frankl. Frankl observed in his book, Man's Search for Meaning, "the size of human suffering is absolutely relative." Having spent years in a concentration camp, Frankl discusses the depths to which humans can survive or give up the will to live. As in life,

there are extremes on both ends of the death-with-dignity, or dying, spectrum. Some might feel dying should be drawn out as long as there is any possibility for life. Then there are those who know when they've lived a long life and would like to call in the chips when they feel their time is up. Any idea what your threshold is (or when you'll know you've jumped the shark)? It doesn't need to be set in stone this instant, but this chapter is about getting you to contemplate quality of life issues. And once you're clear on your own feelings about the subject, then it's time to talk with family and caregivers about it. That way, if a decision needs to be made, they'll have an inkling of what to do.

Since quality of life is such a personal thing, this might be a really easy chapter for you to breeze through, or it might be the hardest in our end-of-life discussion. Either way, it's your decision to make, and it is also the most important information to discuss with your family, loved ones, and care providers. Different life circumstances might influence your answers to the questions in this chapter, including: religious beliefs, pain threshold, age, monetary considerations, etc. The gift of you taking the time to fill this out is that your family will hopefully be much more comfortable knowing what you wanted for yourself versus flipping a coin (just joking—sadly, it's more likely a fistfight would be involved). Sorry, this might take some power-pondering, but it is really important that you finish this chapter—so whatever it takes . . . please.

Hospitals 101 (The Basics)

Hospitals are places where doctors and nurses work to make people better. Or at least that is their goal. This environment is designed and set up to save lives and attempt to "cure" people. What's important to understand up front is that hospitals are buildings, and doctors are people . . . no more, no less. Therefore, ultimately, it is your responsibility to decide how you want to utilize the facility and their expertise. Because of all the advances in science, it is now possible to keep food viable way past its natural expiration date and, for better or worse, it's the same with people. If you ask medical professionals to keep someone "alive" for the greatest length of time, you'd be surprised how long they can keep a heart beating and a set of lungs breathing. So the question becomes, what is their role and what is yours?

It's really pretty simple. A doctor's role is to make sick people well. That is, after all, why they endured grueling medical school and residency. (Either that or they have a fetish for those fabulous white coats.) I think it's reasonable to assume the majority are there to help mankind through the practice of lifesaving medicine. It only makes sense then that since they went to all that trouble, rarely are they not going to try to save a patient through whatever means possible (especially true of doctors who are specialists or surgeons). This is excellent news the majority of the time, and especially great if you're a 33-year-old mother of two young children with a diagnosis of breast cancer. If you're an 89-year-old man with liver failure . . . maybe not so much. And this is where conflict can come into play. Just watch one episode of Grey's Anatomy and you'll know how far doctors will go to, let's say, get a heart restarted. Exciting, miraculous, and awe-inspiring . . . yes; but also a truly brutal reality when they're your ribs being compressed or your chest being cut open. So we're clear, doctor's role=whatever it takes to save someone. That is, unless you indicate otherwise. Which leads us to your role . . .

Your role is to have thought through ahead of time how you

feel about life support and aggressive life-extending medicine. Sounds pretty basic, but most people don't spend much time and energy on it, and that's why it can be chaotic and agonizing when illness strikes. And as brilliant as they often are, doctors are not mind readers or gods. I mean, is it really fair for you to ask them to make a decision on your life support when you weren't willing to take the time to contemplate it for yourself? That's way too much for you to ask of a mere mortal (fabulous coat or not!).

A couple of other things you should know while we're on the subject:

The majority of Americans die in hospitals, even though studies show that more than 7 out of 10 people say they want to die at home. All I can say is . . . poor planning, people!

Hospitals are businesses and institutions that make money (even not-for-profits need to fund themselves), and doctors make their living tending to patients. Not that there's anything wrong with that, it's just something to keep in mind.

Hospitals must inform their patients about advance directives, but it's up to you to make the decisions or "opt in" by filling them out.

It's important to have a discussion with your doctor regarding how she feels about end-of-life care and life preservation. It's not important that she agrees with you, but it is important she understands your wishes and has agreed to honor them.

It's great if you have a good and open relationship with a primary care physician or family doctor, who can act as a sounding board when a specialist recommends a life-extending procedure. Often the primary care doctor can advise you on what some of the trade-offs might be.

Most doctors get limited education in end-of-life care and how best to medicate dying patients (a good reason to consider hospice—see p. 72) so consultation with a palliative care specialist is helpful regarding pain management when terminal.

Nurses know a lot and aren't afraid to tell you; just ask. Do yourself a favor and appreciate and utilize nurses for all they have to offer.

Hospitals have a never-ending round of doctors and health care professionals that you can be referred to. That's why it's up to you to decide for yourself when enough is ENOUGH! And also why you are your best advocate (or your proxy is, on your behalf).

DNR's cannot be expected to be honored upon arriving at the emergency room or when 911 is called. Emergency personnel are there to save lives, and can usually not take the time to sort out the validity of-or wait for your family to find-a DNR on the spot. If that's not what you want, reconsider going to the ER or calling 911.

Hospitals have on hand ethic advocates (or committees) that can help advise families in disagreement to think through their decisions. If you ask your doctor or hospital, they can refer you to one.

The law requires that your decision to refuse treatment be honored or the institution must make arrangements for your wishes to be honored elsewhere.

Food for Thought

While researching and interviewing people for this book, one of the most interesting and eve-opening things I learned was best summed up in this quote by hospice director Nancy Capocy, RN:

People aren't dying because they are not eating, they are not eating because they are dying.

When we are nearing death our body starts to shut down and can no longer process food and liquids efficiently. We, as caregivers, think we are doing our loved ones a favor by nagging them to eat and drink. The opposite is actually true; instead, we are making them more uncomfortable. Since their organs are not fully functioning and are shutting down (a totally natural process), their lungs may fill with fluid, causing their heart to work harder, making breathing more difficult, and increasing their discomfort. Or they may become constipated and bloated if forced to take in food and liquids that their body is not able to digest. This can lead to impacted bowels that might need to be manually disimpacted . . . need I say more? To make people more comfortable, usually all that is needed is to moisten their lips and mouth (a swab or ice chips will do the trick). The body, in its brilliant design, will make it clear when it needs nutrients to keep

strong and heal; otherwise it will release endorphins to work as pain relievers during death's final stages.

Quality & Quantity

Now that we know we can be kept alive for longer than a Twinkie is edible, we need to decide if that is what we want for ourselves. Do you want to be kept alive as long as medically possible? Do you want to refuse any or all life support? And what do you consider life support anyway? Besides the basic things we think of when we consider life support, like artificial nutrition and respiration, there is also the line of secondary treatments to keep in mind. Some examples might include: Do you want chemotherapy to prolong your life a few weeks when it might make you sick for the length of that time? Do you want dialysis when you have a few days to live? It's not important to spell out every scenario, but it is important to be clear on how you would define a life worth living for yourself. Or more directly, what is it okay to die from?

Even though last chapter we discussed what a Living Will and Advance Medical Directives are, let's take this opportunity to get into the nitty-gritty of what decisions might need to be made. We'll start off with your thoughts on basic life support.

Feeding Tube—used to supply artificial nutrients and fluids when you are unable to eat or drink. The tube is inserted either directly into the stomach, through the nose into the stomach, or intravenously.

Okay to use []						
Only if temporary while healing	[]				
Don't want []						

Further thoughts:
a da datable sa databan katama garrab eranda da
manufe to made
Dipper action to tolera and the office of the second second to the
en fabilità set sone e a sollere sent trabació y bajaren addin a
of Oldings vitesian to more, separate or or manner of
e de como e grada el cultur. El rescriba cara lus tre e su persona el filos y mo. El esprintir son acatives para el cara delina el filosoficio en que de cara el filosoficio.
Ventilator—a machine that forces oxygen through the lung when a patient is unable to breathe on their own. This is usuall what people call the <i>plug</i> , as in "pulling the plug." (This is no the same as inhaling oxygen, which is often given to provide comfort in breathing.) Okay to use [] Don't want []
Further thoughts:
bullity frames to provide a provide a provide a second of the
tapper per tembergo and consistent and participation of the periods. Sometimes
<u> Alguni Mel ett kan anderla seneral gan ettetyt kan et fra get in om</u>
The case and a paint readers and guidette story entire no sector if the
All this banker of the Palace to as a sense of the
Secondary Treatments—there is usually something doctors can
do to try to treat you. If you are not going to be cured, how do you feel about secondary treatments (i.e., dialysis, chemotherapy antibiotics, going off non-essential medications)? Anything it takes []
Only if good % for recovery []

68 MY LAST WISHES

No []	
Further the	oughts:
	entin getinbasii koorbina ee ligabaha ee ii—maanab Aan tarah
	A WELLEY CONTRACTOR
chest comp heart funct ten by you form these	diopulmonary resuscitation often involves external pressions and electric shock when trying to restore tion. A <i>DNR</i> (as noted in last chapter) is an order writer doctor to the health care professionals not to perprocedures on you. Int a Do Not Resuscitate (DNR) order issued? [N]
Further the	oughts:
Path such	or redsong that is not disposition or the regestment
Water an	rug de gratadisserva a des 250 apriles or legam of
	god mad no The prosour frequency may and word

ministered to keep you comfortable? [Y] [N]

Further thoughts:
Assisted—If it were legal, would you like drugs administered to hasten your death? [Y] [N]
Further thoughts:
en de la companya del companya de la companya de la companya del companya de la companya del companya de la companya de la companya de la companya de la companya del companya de la companya del companya de la companya de la companya de la companya de la companya del companya de la companya
Time Factor—If you opt for life support, how long do you want the above measures honored? (i.e., Until doctors agree there is no hope for improvement, specified amount of time passes, if over certain age, or no limit)
Monetary Concerns—Although your life is priceless to your family, medical problems are cited as contributing to approximately half of all bankruptcies in the U.S. Even if it's crass, you need to know what your financial situation will bear. Your thoughts:
The control of the co

Knowledge—Son	netimes ignorance is bliss and sometimes I'n
_	ow. How about you? Do you want to know you
are dying? [Y	
How blunt do yo	ou want your family and caregivers to be?

Mind Me Asking?

How's your aura? Let's talk MBS (mind-body-spirit) connection for a minute. Don't worry, I'm not going to suggest you go all holistic and take to chanting, but many studies show there is something to it. And since we're talking medically, it's important to note that our spiritual well-being (religious or not) plays into how we feel mentally and physically (not to mention aids in pain relief in many instances). With this in mind, you might want to incorporate meditation, prayer, scents, massage, and other services and practices that help calm and center you. Mindfulness (being present and in tune with your surroundings) alone has a huge effect not only on your wellness, but also on your ability to appreciate whatever amount of time you have in our wondrous world. This is rarely something a doctor can or will talk about freely, so you'll have to pursue these topics on your own.

good therapis can help reliev	t. Not only ove anxiety an appreciate the	can your do nd depressio	ctor provide n, but a clea	tor or speak to medication th ar mind can he living. Though	at lp

Hospice Care

Hospice is a philosophy of care that is built around a team approach to pain management, symptom control, and death with dignity. Hospice care is provided in one's home, freestanding hospices, or at institutions such as nursing homes and hospitals. The main emphasis associated with hospice is *palliative care* as opposed to curing illness. Palliative care refers to providing comfort through pain relief and symptom management. The hospice team consists of doctors (medical director), nurses, health care aides, chaplains (can arrange visits from various religions), social workers, and volunteers; they are usually available 24 hours a day to answer questions or in case of emergency.

As one of the most underutilized services in end-of-life care, hospice is often not called in until a few days before someone passes away, which misses the whole point of what is available. Here is a brief run-down of the services hospices offer:

- Nurses for pain and symptom management and communication with your physician
- Certified Nurse's Assistants for assistance with personal care: bathing, hair care, nail care, oral care
- Training for caregivers
- Social worker for emotional support
- Chaplain for spiritual counsel
- Medical equipment (hospital bed, walker, oxygen, etc.)
- Bereavement services for family

Since this service is covered under Medicare and Medicaid for anyone who has six months or less to live, everyone who is dealing with a dying loved one should, at a minimum, be aware of what is available in their community. There is no harm in finding out about the services that are offered since you're under no obligation at any time to utilize the program.

The majority of doctors themselves would rather be in hospice care at home than die in a hospital. (Okay, so I don't have an official survey on this, but the doctors I've spoken with agree, so I urge you to ask your doctor; I think he'll back me on this point.) More often than not, though, families are regretful that they did not call on hospice earlier in their loved one's care. Note: It's possible for people to live longer and more comfortably in hospice care versus in a hospital or under no care. Piqued your interest? Learn more about hospice by asking your doctor or by visiting the National Hospice and Palliative Care Organization (see Resources).

Does ho of life?	spice so	ound like so			like at the	
What are		general thou				
			žino si	Dung (SA)	men of	
		Physical College	itootsako:	756	ruspisk.	
		11	616,474,50	Carrier (1)	and r	

Organ Donation

Using that kidney? Do you mind if I do? Okay, probably not me, but someone else might enjoy it (and I don't mean with a nice Chianti). There are over 120,000 people in the United States alone awaiting an organ donation each year. You'd be surprised how many lives you can save by offering this gift of life. Currently the best way to indicate your preference to donate is by having it noted on your driver's license (or if you don't drive, by carrying an organ donation card). Obviously the most important thing to do is to notify your family of your wishes so they are not taken aback and creeped out when an ER nurse asks them if they can give your liver to the lovely lady in room 104.

Although a few religious traditions don't promote organ donation, most have changed or loosened their stance on this because of the many lives that are saved. If you are at all concerned about whether donation conflicts with your faith, please talk to your clergy person or spiritual advisor to clarify. Of course my view is the more people who can enjoy the wonder that is me, the better!

Do you want your organs donat	ed? [Y] [N]
Any specifics you'd like noted:	

Notes

Anything more to medically speak of?

CHAPTER SIX

GOING, GOING, GONE

ant the good news? You're not dead yet. But I'm not going to lie . . . it's not looking good. The doctors have done everything they can, so now what? Well, let's decide how you want those last few days to go. (Yes, I realize that many of us don't have enough advance warning to perfectly plan our last days, but let's just say we do. Come on, no one likes a death pooper!)

Going, Going . . .

As in grammar school, it's always good to start with the nouns: people, places, and things. In other words, who and what do you want around you and where would you like to be during your final days here on earth?

Lunch to Go: One of my close friends had an uncle, Connie (short for Cornelius), who knew he was dying of terminal cancer and was determined that his last days be wonderful ones. Each day he rested all morning, then had his loved ones come for a lunch visit one by one or in small groups. He discussed how much he loved them, asked them what their favorite memories of him were (and shared what his were of them), and then asked if there was anything he had ever done that he needed to apologize for. When my friend came home that afternoon she said it was one of the best afternoons she has ever had (her tears of sadness were overcome by the ones of joy). Nothing was left unsaid, there was complete closure, only love and peace was left. It was such a profound experience for her entire family that they have shared this story with many of their friends and have vowed that's how they want to spend their final days. (It's not necessary to be terminally ill to incorporate this into your life. Who's waiting for a lunch invite from you?)

Say It's Okay: Many experts agree that people need to know two things before they are able to die peacefully: permission from their loved ones to go and peace that their loved ones will be okay when they are gone.

Sometimes even that is not enough. In Ira Byock's book, *Dying Well*, he speaks of people often waiting to die until they are complete with their lives, and uses a guide referred to as "the five things of relationship completion." They are: I forgive you; forgive me; thank you; I love you; and good-bye. By using these sayings as a guide to completing any unfinished business in their lives, people often find they are more ready and able to transition into death with peace.

Any ideas on what you might need to be	at peace?
	29. 18.
en aria de la seguina de la compania	
and the state of the supplemental trace in a State	and the specific of the second
White the late of Art 1900 and Art 1900 and Art	un marchine de la viela la
A STATE OF THE STA	TRANSFER 1/ 4 SELECTION
Who do you want to visit you during you	ur last days?
Would you like to be visited by a spiritu of the clergy?	al advisor or member
and an element of the first of the	r i Males radio dese
The second secon	

Is there a tradition or ritual you would like performed? Specify.
Even when at peace, people sometimes wait for their loved ones to leave the room before they actually die. Would you ideally like someone with you or would you rather be alone at that final moment? Keep in mind this is only a preference. Chances are you will not have a perfect 5:30 p.m. (when everyone is finished with their work and comes over because today is the day you are going to die) moment.
Who do you want at your side when you pass?
Constitution in the second of

Places

I'm not sure about you, but I think my bed is the most comfortable place in the world. Sometimes on a Sunday morning (when I know I have at least an hour before I need to get up) I

hink I've already died and gone to heaven. So that is definitely here I hope to take my last breath. How about you? Where ould you like to be when you know your life is winding down?
และนักสูงสัมมิที่มีการแรก คระเมินสมัยเหตุการสมาชาการสมาชิก อย่ายให้สุดถนา
si santanggan, sagawa na patataga ta, atawanibwahna sa italia
Syou're physically up for it, are there any final stops to make or rips you want to take before you go?

Not on My Shift: Oftentimes families cannot take on the responsibility needed to have a loved one at home to die. Although surveys say that 70% of people prefer to die at home, less than 25% do. As previously discussed, this is a great reason to look into hospice or other arrangements.

The other interesting thing to note on this topic is that some nursing homes and assisted living facilities make claims of low mortality rates on site. By claiming low rates and bragging about everything being done to assist their residents, they miss the point. Rushing dying people to the hospital is not exactly ideal.

Wouldn't it be better to boast about the fact that they serve their residents well until their last moments on earth? It might be more comforting to know that they have a high rate of letting people die where they are comfortable, instead of being transferred to a hospital to pass away. Just something to be aware of and to clarify when you are looking into where to spend the last years of your life.

Things
What "things" would you like around you (i.e., favorite blanket, photographs, flowers)?
The relative recording to September 1975, and the rest
Hearing is often the last sense to go. Is there music or other sounds you might like to have around you? Would you like someone to read a book, prayer, poem, or anything else in particular to you?
<u>ander 2 de la comitació de la</u> Anota de la comitació de la co
and the state of the second of the second Second of the second of the

TIPS FOR LOVED ONES

People die as they have lived their lives—let them be who they are. All they want to know from you is they are loved and accepted as themselves. There is no secret formula, just be loving and present.

People who are restless before they die are oftentimes looking for closure about something. Ask your loved one what they need to be at peace. Or try to gauge from what clues they drop if there is someone they need to see or something that needs to be said.

Do not interrupt, correct, or deny the feelings your loved one is expressing when they are dying. It's just plain rude! Besides they might be trying to tell you something and you might miss it by labeling it "hallucinating."

No one wishes to be "saved" or "rescued" on their deathbeds. If they are religious or spiritual, they will lead the conversation. Don't impose your views. It does not bring them peace, and this is not about you (unless you are also dying on the exact same time schedule—then what the heck? Go ahead.).

A nice foot rub or hand-holding can mean the world to those who are ill. (One of my nice memories of when my grandmother was passing was rubbing her feet.)

Iust a little pooch prompt: Someone needs to step in to take care of the house and pets if a loved one is in the hospital (in Chapter 8 you will decide on a permanent guardian).

So the bad news is . . . you're now dead[®]. The good news is you've lived a wonderful life—congrats! Now what? Well the first thing we need to decide is what to do with your body.

What to Do

If you die at home expectedly, from a terminal illness, your doctor or hospice team should be your family's first call. Once a doctor or hospice has been informed, there is no rush to have the body removed until your family is ready to call a funeral director or other professional (I mean a couple of hours; any longer and it poses a health risk for family and funeral personnel). If you are going to be cremated, this is a good opportunity for your loved ones to gain some closure by seeing you one last time; it might be the only private time that can be arranged with the body.

If a doctor or hospice team has not been involved, then police or 911 should be called—at which time they will advise your family what needs to be done. You will then be declared dead by a doctor, nurse (hospice), or coroner/medical examiner, and a death certificate will be issued, at which time the funeral arrangements may begin.

FYI: Death certificates are documents issued by a government official stating the date, time, location, and cause of a person's death. They are needed in settling an estate's legal and financial issues. Depending on how much is involved, 10 copies is usually

This is only a drill. If this had been your actual death, you'd have been instructed where to go (or not) and would most likely not still be holding this book.

a safe number to have certified (more if there is a lot to get settled). They typically run around \$20 for the first copy and about \$5 for each additional.

Autopsy

Discuss under which circumstances you think an autopsy would be appropriate. Keep in mind it's usually not your decision. But you might want to give your loved ones your blessing to find all the answers they want, or you might feel you'd rather not have one.

[N]					
Notes:					
		See St. States and	A CONTROL OF	i i	

Would you like an autopsy if your family wants one?

Notification

When is it okay to call my parents' house past 10 p.m.? When and only when someone has died (now I'm guessing they might make an exception if one of their children won the lottery or were in jail, but chances are slim for either scenario). Most people will forgive the faux pas of the late call in lieu of being excluded from hearing the news that a close loved one has passed. So go ahead and make the call.

Who should be notified immediately when you pass? (Imme-

diate family, friends, work, organizations, etc.) Put a star next to anyone who could assist in the phone tree.

RELATIONSHIP	PHONE #
	And And State of
e um Altabie (m bolio etc	(ADITE AND ON TO
14	
	7 77 May 2 26 Color

RELATIONSHIP	PHONE #
oro bay wayes sindonse.	
offeren and Awarenburg	TOTAL THE SECOND OF
kacang bay sagaran can	ur limites and the track
on the engladors of first	aparthalant

By the way, where do you keep your address book?

Funeral Arrangements

In the next chapter, we will plan the "big party," but first we need to make a few prearrangements. With the average funeral costing around \$7,000 (many over \$10,000), it's important to consider your options with as clear a mind as possible. When making funeral arrangements for yourself or your loved ones, rarely are you going to have enough practice to be great at it, so here's a little information to assist you.

As with everything else in life, there are great and not-so-great funeral homes and funeral directors. It's helpful to keep in mind that while they are often compassionate kind people who are there to help you . . . they also run a business. You should be aware that many funeral homes and cemeteries that were once family-owned are now owned by huge conglomerates (and, as

such, are money-making investments). If it matters to you, look for "family-owned and operated" versus "family-operated" or no distinction (usually corporate owned and operated). Here are a few facts and tips to keep in mind when you are planning.

Good to Know: The Federal Trade Commission has several laws governing the funeral industry. A few you should be aware of:

Funeral homes must give you pricing over the phone and a price list that you can take with you if you make a visit in person. Don't be embarrassed to comparison shop (it's often said that this is the third biggest purchase in a person's life—so to speak—next to a house and car. Or fourth if you paid for a huge wedding.)

You are not required (with a few exceptions) to buy any service or item you do not want. You are also entitled to an itemized list of all goods and services you have agreed to at the time of the meeting. (Make sure they note in writing anything added in.)

You can buy a casket from an outside source and the funeral home must agree to use it. They cannot charge you a fee for not purchasing it from them. (There are some beautiful unique caskets and urns online that can be overnighted at a real cost savings. Or you can order one through Costco for goodness' sakes!)

Funeral directors must notify you that embalming is not legally necessary and under what circumstances they require it (if service not held shortly after death). It's definitely not needed for cremation.

They must show you a list of caskets they sell before showing you their displays. They often only display the nicest (read: priciest). They must make a plain box or similar container available for cremation.

No casket or burial vault (or liner) regardless of quality or seals, will preserve a body forever, and funeral directors can't imply they will.

Tips to keep in mind

Emotional overspending happens so easily. When making arrangements for someone else, or even for yourself, take a friend along who can serve as an objective observer.

When planning a loved one's funeral, don't be pressured by phrases like "I know you want the best for her" or "Typically this is the package that someone with your father's prominence would choose."

You're not stuck. If you're unhappy with the funeral home that took in the body, you can have a separate funeral home take over (there will be a charge, but your peace of mind is worth it).

Veterans are eligible to receive a free burial and a grave marker in a national cemetery. (See Resources for contact info.)

Prepaying for funerals or cremation is usually not a great idea. It's better to open an account that is "payable on death" (POD) at a local bank in the name of an adult child or the executor that will allow them to pay for funeral expenses immediately. Your bank would be happy to help set this up.

Cremation

Cremation is an alternative to burial that is becoming more and more popular in the U.S. Out of all the deaths in the U.S. in 2013, more than 64% of people were cremated in states such as Arizona, Montana, and Washington (the U.S. rate overall was 45%). In England and Japan cremation rates are over 70% and 90% for the same time period. The cremation process takes place when the body is put in a heated chamber where it will disintegrate into what remains of bone fragments (takes about 1½ to 3 hours). The results of this process are called cremated remains or "cremains." These cremains can be processed to even finer consistency if you will be scattering them. The cremains weigh about 4 to 8 pounds (about 200 cubic inches in volume or about the size of a shoe box) and are, when processed finely, about the consistency of coarse sand. Even though they are referred to often as ashes, they do not blow into the wind like the word implies.

Since the consistency is dense, scattering over a golf course or Wrigley Field is not welcomed (think anthill mound versus ashes flicked from a cigarette). There are also some state laws regarding scattering cremains that usually include: that it's okay on private property (yours, not Elvis's), public property that is not inhabited by people (some restrictions apply), or 1 to 3 miles off shore of where people live. Although I would guess it's hard to get caught or prosecuted for this, I am still going to recommend that you check the local regulations before you disperse with dear Uncle Bill. The cost of direct cremation is around \$1,000.

Combo Deal

Some people like the idea of being cremated but also like, or are used to, a traditional funeral service that includes a wake and visitation. No problem. You can have whatever combo you want, or, shall I say, are willing to arrange and pay for. A funeral home can rent you a casket, set up a traditional wake and then you can be cremated after, with either a separate memorial service or just have the cremains returned to your family. Again, your religious obedience, creativity, and personal preferences are the only limitations on the possibilities of choosing whatever works best for you and your loved ones.

A Few Remainders

Remember, if you scatter someone's cremains, they are gone for good and cannot be retrieved. You can opt to have half scattered and half (or whatever %) kept for the family to memorialize their own way.

Memorial and Cremation Societies are nonprofit organizations, usually run by volunteers, that help provide information and cost savings arrangements to consumers. They can be found on the Internet or in the phone book. (Beware of for-profits that are just businesses using the word "society" in their name. There is not necessarily anything wrong with them, but know they are just businesses providing a service versus offering impartial information.)

It's a good idea to find out how the funeral home or cremation facilities carry out their procedures to ensure that you are comfortable with their reputability.

Cremains pose no health risk and can be handled without fear of smell or disease. Because of differing opinions or multiple families, it's not uncommon for cremains to be divided among family members.

You can buy custom-made urns in decorative designs, jewelry that hold cremains, and even diamonds made from cremains. This is a growing market, so there are almost unlimited possibilities. And if you have your own idea that no one has tapped into, you can usually find someone who will make it happen.

anyming eise vefore we get going to the next inapter?				
Notes				
				49 3 3 3
	400			•

CHAPTER SEVEN

THE SERVICE

ave you ever been to a funeral where you just knew the person wasn't being represented true to the life he had lived? Sure, maybe the funeral home was tacky or maybe they had a crummy florist, but most likely . . . it's his fault! I know he's dead and all, but if you don't plan, that's what happens: a free-for-all. Think about it . . . his loved ones are in mourning. They can't possibly be expected to make all the right decisions under those circumstances. And even though none of us is going to get the Princess Diana version even if we planned it down to the last detail, we can at least help out our poor loved ones with a few details. This chapter is about your wishes for your service and includes a helpful checklist for your family or you to use when planning for others.

Since there are many different customs and traditions that vary from religion to ethnicity and even to geography, think of this as a general inquiry and feel free to personalize it as you like. Let me tell you even within my immediate family there is a huge

range of observances—everything from loud and slightly raucous (the Irish side) to a dignified luncheon after mass (the Italian side). There are even a few non-traditionalists, like my favorite brother-in-law, whose dream service includes only lots of stories, laughs, and adult beverages. The majority of Americans are still going to go for the ol' classic wake-then-funeral, which, don't get me wrong, is nice and all. There is, however, a change that's a-coming . . . I like to refer to it as the ME-MORE-ial service. That's right, more "ME" (actually-you) than has ever been incorporated into an ordinary service before. After all, you are the guest of honor, so why not make it more personalized, a real reflection of how you and your family want to honor the life you have lived. I explore a few non-traditional options at the end of the chapter (you might want to glance over them before you start filling things in). I say to each his own. That's the beauty of deciding for yourself.

We'll start with the big decisions right off the bat. . . .

and the comment of the property of the comment of t
Date i sagina na jindasili nga sa na kasa na na na na na
Do you want an open casket? [Y] [N]
Where do you want your final resting place?
Allowers and an own series (Lift busy suger, to only a system
A probability of the state of t

If cremated, what do you want done with your cremains?
to the company of the state of
marking to all the same as a same as a final filteration base.
Now get ready for possibly the most important question next
to what to do with the body (but in many eyes equally as
important). What outfit do you want to be your last outfit?
The state of the s
Hopefully your last party will be years from now, so in case the
outfit is no longer in your closet or up-to-date let's also have a
plan B. (Warning: Your executor might be organized and a good
choice to handle for your estate issues, but that doesn't mean he
or she has any fashion sense.) Who would you like to choose you outfit?
outner.
<u>an anna an aire in an ina aire an an t-un an aire an </u>
on a tampy to the first of the state of the state of the state of
gringston og komer och medigare ik Vinglister sakt takting och
Any color preferences? Any style that looks best on you?
This color preferences. This style that looks best on you.

Don't laugh. Sure, it seems unimportant, but that will be the last outfit people will see you in, and most importantly it will be what you will be wearing forever.

How about the bling? Is there any jewelry you want to be
buried wearing? (A quick note on jewelry: I have heard more
than one story of people upset that jewelry was left in the coffin.
Wouldn't someone you love enjoy it more? Still your choice, just
wanted to mention it.)

Okay, now that you're taken care of, let's think about the partygoers.

A few years ago my best friend Cheryl's sister, Linda, went to a wake with a huge turnout and was very upset thinking of her own service and the fact that she doesn't even know hundreds of people. She got so upset thinking she was going to be a loser corpse that she called Cheryl and made her do a "who would come to my funeral" list. (Don't pretend you've never done one!) After her relatives and friends totaled fewer than 60 people, Linda asked Cheryl, out of her friends, who did she think would come? Cheryl called me later that day to make sure that when Linda died I would be there, and by the way, did I think I would be bringing a date, since that would up the numbers? I said not only would I be there, but, loving Linda like I do, I would also like to partake in the ceremony if possible. Was there an opening for a singer . . . maybe a little "Ave Maria"? After a few calls back and forth I was informed that, although my presence was extremely welcome, my singing was, in fact, not. And long story short, since my musical stylings have been barred, I keep insisting

that I will now unfortunately be forced to perform some form of interpretive dance to express my sorrow at her loss.

So what's your version of your final party? The people in your life won't be able to guarantee *everything* is done to your liking, but then again you'll be dead. Don't think of it as morbid . . . think of it as helpful to those you leave behind.

Who do you want to perform the service? Favorite clergy Other options?	person?
Line 20 (Izaniwa swazi orzekt new blim w grawest to act	d midty)
Where do you want your service to be held?	
the soften is found to allow with more Plantin will be	511 31/
Who do you want to give your oulogy?	
Who do you want to give your eulogy?	lestelle
	/
Any other speakers?	
Any special poem or prayer read?	

and the same	an inamabi samusa 1904 dayab arat samapat kanyak ya 2
	ionices, weighted the control control protection
	- The state of the
Who would	d you definitely like at your service?
,	
114	
What do y	ou want your obituary to include?
Where wo	uld you like it posted? Newspaper, social media, other?

Any special requests not covered? (charles) (c	
The state of the s	<u> </u>
and the second	
	Village Commission (Commission of Commission
TO THE STATE OF SHORE THE	

HOPEFULLY HELPFUL HINTS

Have a Plan. Most of the service can be self-planned far in advance. So why not have things the way you want them by making prearrangements? Talk to a funeral director who can help with all of your pre-needs. Or call an event coordinator for tips on a non-traditional service (check out Celebrants—p. 105). Preplanning is truly a generous and financially responsible thing we can do for our loved ones.

Panties Please. Don't forget the undergarments. Most people forget them and that leaves it up to the funeral home to let you go commando or charge you for it (and who knows what kind they have lying around?). Besides, do you really want to run the risk of going through eternity with a wedgie?

Kids' Contribution. Young children often feel helpless when a grandparent dies. A nice idea is to have them draw a picture they can leave in the casket or at the service so they can feel included and express the loss in their own way.

Grief Strikes. People handle grief in different and sometimes odd ways. (I myself have been known to laugh at inappropriate times . . . in my defense this happens at weddings, too.) Try not to judge or take things too literally. Not everyone will be composed and strong, so let them grieve in their own way.

Watch It. Thieves check obituaries to see when people aren't going to be home. It's a good idea to have a house sitter for anyone mentioned in the obit (at least ask a neighbor to keep an eye open).

even had a lengthy discussion and she's agreed to it. Once you're gone, if there is nothing in writing, all bets are off. In my circle, more than once has it come up that people did not receive what they were promised or anticipated receiving. Bottom line: if you want someone in your life to have something of yours, either give it to them while you're still here or spell it out clearly in your will.

Keep in mind:

If you're in a relationship with someone, but not legally married, you cannot count on that person having any rights to possessions or any other decisions that are made. Your family can completely exclude your partner if they want to.

If you leave all your money to one person and they are expected to give it away to others, there might be tax consequences for them or the people receiving the money (see Gifts, p. 128).

Below we're going to start assigning who gets your *things*, but just to clarify . . . this is a practice exercise. For any of this to be legal, you must put it in your will. Okay, let's begin:

This:	<u>Landaghal d</u>	Goes to:	entrale de la
Note: _	galerica bas	Serohaur at the more in-	
		What this section is	7. 80.5
This:		Goes to:	App 2
Note: _	dal del artico		

- ☐ Pictures to be displayed. (Some people also like to display military medals.)
- ☐ Special music (if desired) instead of normal background music.
- ☐ Guest book if there is a special one that should be used; otherwise, it's provided by the funeral home.

Non-Traditional Options

I mentioned my favorite brother-in-law and how he hates wakes and funerals and has specifically vetoed any such event. The exciting news is with the cost on the rise for traditional funerals—as well as creative alternatives spreading by word of mouth—there is no end to the ways to honor and celebrate someone's life. I say "honor them" because that's why we have a service in the first place. And although religion, tradition, and fear of disrespecting someone has kept us looped in the same old, same old, you might be up for something different. Below are a few suggestions of festivities that can be held in lieu of a traditional wake, funeral, or sitting shiva (Jewish tradition). Although there is a huge range, think about how much going non-traditional can save in terms of dollars (the average of \$7,000 can buy a pretty nice dinner) or increase as far as warm memories.

Celebrants

A celebrant is what the name implies, someone who helps celebrate an event (or officiate at various rituals or rites of passage). Celebrants are huge in Australia, where they perform a large portion of the wedding services that take place. In a funeral situation, they are hired specifically to serve as a storyteller or eulogist on behalf of the family. They meet with the family after a death (or, if foreseen, beforehand) and interview them to capture what they want conveyed about their loved one. Then this information is woven into a speech or story as a tribute presented by the celebrant during the service. Celebrants are trained to incorporate the deceased's traditions or spiritual beliefs into the ceremonies they conduct.

Memorial Services

A memorial service is usually held after someone has passed to honor them either in lieu of or in addition to a funeral service. It is a long-held belief that a memorial service or some other type of event, where people express their condolences, is an essential part of the mourning process. But no one says it can't be whatever you want it to be. The nice thing about a memorial (or *me-more-*ial) service is that it can be held anywhere and incorporate any expression of the person. For example, if someone was an outdoorsman, the service could be held in a park or botanical gardens. If the person owned a business, it could be held on site. The emphasis of this type of event is to focus on what reflects the life you've lived. Here are a few non-traditional ways to memorialize someone that can reflect and serve as an alternative to a regular memorial service:

Fancy Fare. Instead of accompanying a funeral, a special meal (dinner or luncheon) can serve as the entire event. Think about how lovely it might be to have your entire family and friends treated to a nice dinner at a relaxing place where hours can be spent visiting and enjoying a good meal. The room could be decorated with all of your favorite things, including lots of photos, and people could toast and tell stories about you into the night. The cost can

often be less than viewings and wakes that last only a few hours and don't even serve hors d'oeuvres.

Theme It. As mentioned, sometimes people have a special passion or interest that truly reflects the way they've lived their lives. You can take one of your favorite places or hobbies and build a service around that theme. Some examples might be having your service at a winery, a bowling alley, or airplane hangar. You can have your cremains (or other form you plan on taking) incorporated into the event. If you're being cryogenically frozen, how about serving snow cones? Being encased in a sarcophagus? What about a toga theme? Oh, the endless possibilities . . .

Which people can come and express their condolences to your loved ones. But after a nice catered visitation held at someone's home (food and springing for a cleaning service can be relatively inexpensive), why not have the family celebrate your life with a nice cruise where they can relax and recover from your loss? Or maybe you're the trip-to-Vegas type? Let it roll!

Send-off. There are numerous, and slightly odd, ways to memorialize people, especially if you have their cremains to work with. Service options include companies that will disperse them at sea, float them in a helium balloon into the sky, and even send them into space.

Other non-traditional expressions:

Get into the Swing. Instead of people visiting your grave, how about having a useful bench, tree, or swing

set donated to your local park? I've always loved those plaques that read "in memory of."

Take Alongs. Instead of prayer cards, print your favorite joke or saying along with a picture and have it laminated. People will smile and laugh when they see it (smile at you, laugh at the joke).

Hairloom. Although some might not want to carry their loved one's cremains around their neck, how about a locket of hair? Give your loved one a little trim before you send them off and keep them with you always. (No, it is not creepy. Don't you have a snippet in your baby book from your first haircut? Think of this as your last one.)

Flowers, Flowers Everywhere. Instead of people sending flowers to fill up a funeral home, how about supplying a room full of roses or daisies that people take with them after they've come to the service? Or leaving with a packet of seeds (nothing says remember me like forget-me-nots) that they plant in your memory.

Already Arranged

Have you made arrangements in advance?

Preplanned arrang	gements? With _	# 47 (1967), 11() ***********************************	
At:	Constraint of Linear States		

Funeval

Amount prepaid:	terror as mode
Paperwork located:	
Cemetery/Mausoleum	
Preplanned arrangements? With	
At:	
Plot #/location	
Amount prepaid:	
Paperwork located:	
Other	
Preplanned arrangements? With	
At:	
Amount prepaid:	
Paperwork located:	
Any other written instructions?	
Located:	

Notes

Anything else that will help you rest in peace?

CHAPTER EIGHT

YOUR STUFF

hings, things, things. They take up our time, cost us our money, and we often spend more time acquiring and dusting them than we do enjoying them. Not that I reject materialism *entirely* (I do own three pair of the same slippers and numerous books I've yet to read). My point is sometimes we are surrounded by things and don't even see how really fortunate we are in our lives.

One afternoon a few years ago I remember studying the book cover of An Open Heart (which features a very close-up picture of the Dalai Lama's face), and I couldn't help thinking how happy he looked. One of the points I gleaned from this book was how attachment to materialism and lifestyle is a big cause of our own personal suffering. It particularly hit me in one part where he talked about the suffering that people who experience fame endure because when the fame (and wealth) ends it can be devastating to them (how many child celebrities grow up to be healthy members of society . . . okay, besides Ron Howard?). Here was

the Dalai Lama, a man who had lost his country, his sovereignty, and I'm not positive he owns anything other than the robe he wears and the pillow he's often sitting on, and yet he has a smile as warm and brilliant as anyone I have ever seen. When I think about it, he is absolutely right. How much stuff is really needed to live, and how much is just distracting us from what is truly important in life? It's funny because if we look back, many of our ancestors probably came to America with no more than what they could carry in their arms. And yet today we often measure our success and lives by our bank accounts and number of (and emblem on) the cars in our driveways. Boy, we are a silly society.

Okay, that said, our stuff is fun and great and I myself love my things! The only reason I warmed you up with how silly possessions are is because we are about to start giving them away. Not necessarily right this minute, but since you can't take it with you, soon (less than 100 years from now). Actually to truly put this into perspective, we'll start with the most important part of our lives first: our family—children, spouses, and pets.

Children

The reason people put off this conversation is because it's way too horrible to even contemplate leaving your children behind. Luckily, the stats are on your side on this one (besides, rarely are both parents in a family going to die at the exact same time). But you don't get out of it that easy . . . sure it looks fairy-tale-ish in the movies, but no one really wants a child dropped off at their doorstep. And that is why, as unpleasant as it might be, you must assign someone to be your children's guardian if, heaven forbid, the hellish happens.

Besides Julie Andrews, who would make a lovely guardian for

your children? Depends . . . it could be who you think is the most responsible, most financially independent, or who your child feels closest to. Not everyone agrees on what is the most important criteria, and that's why it's so important to pick someone yourself versus letting the courts do it for you. Be aware that anyone can petition the court and ask to be assigned guardian of your children. Do you want your 77-year-old parents raising them? Your peculiar sister-in-law? Okay, then you decide!

Things to keep in mind when choosing a guardian:

- Love for your children and willingness to step up and raise them
- Safe and loving home
- Age and health of prospective guardian
- Least upheaval, if possible, as far as child's location and schedule
- Other children in their household
- Complimentary with your religion, morals, and lifestyle
- Financially, mentally, and physically stable enough to take on the task

Once you've decided on who you'd like to be your children's guardian, it's time to ask the person if they are willing to take it on. Once they say, of course I would gladly take in your little angels, then put this information in your will so that your wishes can be honored. It's also important to have an alternate in case your chosen guardian becomes unable to handle the responsibility.

If you are married, make sure you and your spouse agree on the same guardians. If you've asked separate people, and the unthinkable happens, each one is going to feel compelled to fight for custody and it can lead to a huge mess. Figure out together whom you both feel comfortable with. Maybe you won't get your first choice, but you don't want people fighting over your children. No one wins.

If you're a divorced or single parent you can assume that the other parent will take over custody. If there is an abandonment or abuse situation, talk to a lawyer and put something in writing.

If you're concerned about financial circumstances, one option is to specify that one guardian will raise the children and another will help by serving as a financial guardian. There are other arrangements for different monetary scenarios. For example, you could ask, if there is a large inheritance, that a specific amount be used in the child's upbringing and other money be put in an educational trust, etc.

Remember, this is the responsible thing to do. Don't freak yourself out by thinking about it so much that you don't do it at all. If you have children under 18 this must be done!

Who do you	want to	be vour	children's guardian?	

When did you have the conversation with them?
Their response?
Alternate:
When did you have the conversation with them?
Their response?
Was this information included in your will? [Y] Dated:
Now that we know whom you've chosen, is there any information
you want the guardian to be aware of?
Traditions that are important to you that they continue:

any words of w		
		11F30837 343
	TONE TO	
	To Ar drive insequence of a soul work	Brook billowers
		e Medical Ser
again the second against		
	nt to make sure stay involved in you	
eople you war		
eople you war	nt to make sure stay involved in your	children's
People you war	nt to make sure stay involved in your	children's
eople you war	nt to make sure stay involved in your	children's
eople you war	nt to make sure stay involved in your	children's
eople you war	nt to make sure stay involved in your	children's
eople you war	nt to make sure stay involved in your	children's
eople you war	nt to make sure stay involved in your	children's
eople you war	nt to make sure stay involved in your	children's
People you war	nt to make sure stay involved in your	children's

Feel free to expound on your thoughts in a separate letter to them.

Pet Parent

If something should happen to you, who would you like to serve as your pet's guardian?			
			1988
			Pala ell
Alternate:	320		
Special instructions:			
		er en	
		the control of the following the first and the same	and the second of the second o

Make sure you keep in mind their personal situations and if they have agreed to take on this responsibility. Sure you think Bernie is a delight, but someone else might find him a bite bigger than they can chew.

Spouses

No, they don't need a guardian, but how do you feel about them remarrying? This doesn't mean they will or will not, but it can be a real gift to allow them the freedom of knowing that you would like them to move on with their lives. Please, please don't

debate or fight about this one. And for goodness' sake use a little tact... no one wants to know you have a plan B already picked out or that you often wonder whom you'll marry next. Just, *I'll want you to be happy and move on*, is all that needs to be said.

Thoughts:	
	1949 T. 184 (1947)

Stuff

Finally we get to the goodies! Some might think it's a no-brainer: I don't have anything worth fighting over, or my kids are so close there is no way they would fight over things, or the ol' "I'll let the executor handle it." Poppycock! Ask 10 people and no doubt you'll get at a minimum 4 horrible stories of cousins, siblings, and children fighting over estates that were left unclear.

Bear in mind, you can destroy your children's relationships with each other by leaving them with no instructions on how you want your items divided. Many parents think: I'll assign one child as executor, and they'll know what to do, or I'll just let them each

pick what they want for themselves, or leave no instructions at all. Even more than money, weird emotions come up when people (especially adult children) go through sentimental items that belonged to their loved ones. You never know if two of your daughters could come to blows over a photo album or ring, or maybe they have fond memories and want a particular pepper mill they remember their dad cooking with. That's why it's best to ask each person who is important in your life what they would most like to have and then be clear about who will receive it when you're gone.

If you can't come up with a way that makes you feel comfortable dispersing your possessions, there is always the take-turns method after a fierce game of rock-paper-scissors. Or they can write the top ten things they want on a piece of paper, and as long as there are no crossovers, keep that item (or if there's a crossover, go back to taking turns). However it's done, make sure a system is set up so there's no fighting once you're gone.

Stuff Suggestions

Leave each child and grandchild at least one item that has some sentimental value.

If you know you're dying, consider starting to give away some of your things while you can enjoy the happiness of giving them away yourself. (Don't give away anything that brings you pleasure on a regular basis. And don't give away all your money . . . you never know, you might outlive us all!)

If you want to be super-organized, include a photo in your will of each item you're giving away with the name of the beneficiary on the back.

Don't underestimate the emotions people will have regarding their loss. It might not be the *things* they want, but a part of their loved ones they can tangibly touch. Try to be sensitive to the feelings involved.

If you're dividing things unevenly among your children, they'll want to know why. Don't assume they will know the reason. Same goes for all the grandchildren, siblings, etc. Leaving no explanation is cruel.

Every once in a while, take a nice picture with just you alone with each of your loved ones (children, parents, siblings). This way when you or they are no longer in the picture, there will be a nice frameable image of the two of you. Priceless!

If you have items that your family would otherwise have no need for, ask that they be donated. Some items that are always appreciated by non-profit organizations, shelters, and halfway houses: clothes, eyeglasses, hearing aids, wheelchairs, reusable medical items, books, and office supplies.

Let people know why an item is valuable to you. Include a note in the antique desk outlining its history, or write in the inside cover of your favorite books the significance of what you've learned and why you wanted them to read it, or include a photo along with your engagement ring, sharing with your granddaughter the story of the night you were proposed to.

Tip for today: Every material item has energy attached to it. Things will drain your energy if they're just lying around adding no value to your life. If you don't

love it or find it useful, don't wait to get rid of it. Make decluttering a regular habit. Someone would love to have what you no longer value. Whether it's to your favorite cousin Mark or Goodwill, give away what you think someone else might love to have.

If you have collectibles, don't assume that anyone will know or understand their value. Either spell it out for them or leave instructions that these are valuable items that need to be appraised.

Touchy Tale of Trouble

Inheritors keepers, non-inheritors weepers! I'm sure you think you know the people in your life like the back of your hand, but, alas, you've never seen them when you're not around. Expect that if you name someone as a beneficiary of your stuff or your money that they will be keeping it and spending/using it as they see fit. Oftentimes people think, I'll just leave everything to this person and they'll take care of dividing it. If you didn't want to deal with the hassle of doling out your stuff, what makes you think someone else will? Not to mention, once you leave someone something . . . it's theirs! You might have told them to hand it out or think they'll do the right thing—DON'T! People are known to behave in an odd and greedy way when their emotions (especially grief and loss) are involved.

Being specific about your stuff is especially important to remember when there's a blended family. Let's say you're in your second marriage and you assume your wife will know that you want your adult children and grandchildren to get some of your money and possessions when you go. Let's go so far as you've even had a lengthy discussion and she's agreed to it. Once you're gone, if there is nothing in writing, all bets are off. In my circle, more than once has it come up that people did not receive what they were promised or anticipated receiving. Bottom line: if you want someone in your life to have something of yours, either give it to them while you're still here or spell it out clearly in your will.

Keep in mind:

If you're in a relationship with someone, but not legally married, you cannot count on that person having any rights to possessions or any other decisions that are made. Your family can completely exclude your partner if they want to.

If you leave all your money to one person and they are expected to give it away to others, there might be tax consequences for them or the people receiving the money (see Gifts, p. 128).

Below we're going to start assigning who gets your *things*, but just to clarify . . . this is a practice exercise. For any of this to be legal, you must put it in your will. Okay, let's begin:

This:	Goes to:	POR 14
Note:	Landrage Harris State of the Mindrey of the	al .
		. 4:1
This:	Goes to:	6177 91 - 7
Note:		

This:	Goes to:		
Note:		7 40 2 1	1 1/4
This:	Goes to:		
Note:			9 01/3K
This:	Goes to:		<u> </u>
Note:			<u> </u>
This:	Goes to:		241 T
Note:			
This:	Goes to:		1 1 1 1 1 1 1 1 1 1 1 1 1 1 1 1 1 1 1
Note:			
This:	Goes to:		- 77
Note:			- 10 () 1 (
This:	Goes to:		
Note:			3757
This:	Goes to:		1-11-11-
Note			

This:	Goes to:	_
Note:		_
This:	Goes to:	
Note:		
This:	Goes to:	
Note:		
This:	Goes to:	
Note:		
This:	Goes to:	_
Note:		
This:	Goes to:	
Note:		2
This:	Goes to:	_
Note:		
This:	Goes to:	_
Note:		

This:	Goes to:	100000000000000000000000000000000000000
Note:		
This:	Goes to:	400
Note:		131c3/
This:	Goes to:	286
Note:		A STANK
This:	Goes to:	Mark Control
Note:		<u> </u>
	Goes to:	
Note:		1,034
This:	Goes to:	
Note:		
This:	Goes to:	auth)
Note:		1 11 11 12
This:	Goes to:	
Mata		

This:	Goes to:		- 1
Note:			1 1 1 1 1 1 1 1 1 1 1 1 1 1 1 1 1 1 1
This:	Goes to:		Appliff
Note:			
This:	Goes to:		
Note:			
This:	Goes to:		
Note:			31.175 (2.75) 31.175 (2.75) 31.175 (2.75)
This:	Goes to:	Table	
Note:			
This:	Goes to:	1/1	u. U hate
Note:			<u> Angr</u>
This:	Goes to:	100 miles	
Note:			
This:	Goes to:		
Note:			

This:	Goes to:	
Note:	e a Necesia de la prime April de la proposición de la primeira del la primeira de la primeira del la primeira de la primeira del la primeira de la primeira de la primeira de la primeira de la primeira del la primeira	Alteration services
	Goes to:	
	ienie okazy zakraty. I dogazy na obie	
This:	Goes to:	ga nikeper, kadi kiri. J
Note:		
	Goes to:	
Note:	To bush on a second poor soft	
This:	Goes to:	
Note:	The state of the s	

Deciding on Dollars

Money makes the monkey dance . . . but also makes the people bananas! Really, what makes people crazier than when money is involved? Although you probably have beneficiaries named on certain policies, there is still the cash and other undesignated monies to consider. Depending on the whims of politicians, who knows what tax ramifications are in place when you are reading this, but if you have more than \$1 million there might be some. If you do have that much to give away, don't be chintzy; see a lawyer to make sure everything in your will is spelled out clearly.

Maybe you don't have \$1 million. Maybe you live paycheck to paycheck. Even if you don't think you have a lot, make sure you designate someone to inherit whatever amount you leave.

Gift: There are several stipulations, but if you know your time is winding down (or you're as healthy as a horse and really generous), you can start gifting your money now. You should confirm the current laws, but as this book goes to press, the amount you can gift someone without having to pay taxes on it is \$14,000 per year. You can also gift in larger amounts for special circumstances such as tuition, medical expenses, and in a few other instances. If this might be something you're interested in, ask your tax or legal professional. As with *things*, nothing's legal until the will!

How would you like your money divided:

Amount \$	Source:	To:	120 m
	A Commence		
Amount \$	Source:	To:	
Note:	nunalismi Va mosta	godinan odo soft	eva Proces
Amount \$	Source:	To:	de de la composición della com
Amount \$	Source:	To:	15 med , 2003 34 - 12 - 15
	en al line en en en en en et		

Amount \$	Source:	To:	E Permittee
Note:			
Amount \$	Source:	To:	<u>Qambani.</u>
Note:			10000
	Source:		
Note:			1,000
	Source:		
Note:			
	Source:		
Note:			N. C.
	Source:		
Note:			- 20008
	Source:		
Note:			Suic
Amount \$	Source:	To:	To the second services
Note:			

Amount \$	Source:	To:	
Note:			
Amount \$	Source:	To:	
Note:			1 1 - 1 (1)
Amount \$	Source;	To:	
Note:			
		To:	
Note:			
		To:	
Note:		**************************************	
		To:	
Note:	, A		
		To:	
Note:			
Amount \$	Source:	To:	4
Note:			i glad

Notes	
INOLES	

Anything left to say about stuff?

The second of the second

CHAPTER NINE

NEED TO KNOW INFO

ho are you? No, not in the metaphysical sense. I'm talking about in more routine bureaucratic terms. Sure, we've spent a good amount of time grasping how we are more than just a number, but in this chapter we'll try to capture the administrative side of ourselves. This way, when the time comes for family members to get their hands on the information they'll need, they won't be forced to rummage through the old desk drawers. Getting this stuff together will give them the time to contemplate more important things . . . like how wonderful you were and how much they miss you!

My lucky loved ones won't need to worry about finding my paperwork because, although there are things in my life that might be considered a mess, my record keeping is meticulous. I keep a highly detailed planner and all of my financial and other records are in folders that are labeled and detailed with everything they would need to know. Even so, this section would still be a huge help to them since it has all of the contacts in one

location. At the end of the chapter are some of my favorite organizational tips, but whatever works for you is fine as long as there's at least one other person in the world who can figure out your system (and they plan on living a minimum of a month or two longer than you).

Let's get right to it. . . .

What's your legal name?	
Any other names that you have ever used (i.e., a maiden name nickname, alias)?	
r ital (de se la relegiorario e del colo de Secondificación se	a refeed, colors \\
and the survey of the survey of social	operation state of the
asow, governity, swis atwards by	
What is your current address.	
all es agrerance missons	elektronger er et stept knærkter
	ph #
What was your previous address?	
linnidis kun primin os miss	and the state of t

What is your date of bi	rth?	A CONTRACTOR OF THE CONTRACTOR
Month	_ day	year
Birthplace		
Social Security number	•	
Status:		
Single [] Married [] Domestic Partner [] Divorced [] Widowed []		
Father		Triple state
Mother	m	aiden name
Other		Constraint ven
		er trompes 2
Wedding date		_ location
Children		
Grandchildren		

Siblings
Pets (they may not have legal rights, but my sister insists they be
listed under family members)
Education (name, location, years attended)
High school
- Control - Cont
Graduate work
Certifications
Other
Affiliations
Religion
House of worship's name
Address

Organizations

그는 내용 그 그리고 있는 것이 없는 것이다.	Contact	
Phone #	Office held	
Organization	Contact	
Phone #	Office held	
Organization	Contact	
Phone #	Office held	
Organization	Contact	
	Office held	
Who is your boss?	##	
	##	
	y? [N] [Y]	
	15,01.92	
Discharge date		

Other	
Any other neat notables about you that fill out your biogram, invented Post-it notes, won laribbon for your jam, wrote a best-selling book, hole in or record at the local club, etc.):	blue
	9 9 7 3 1 1 1 1 1 1 1 1 1 1 1 1 1 1 1 1 1 1
Okay, we have your basics. Now let's get down to the nitty-g	ritty.
Savings and Checking	
Bank Accounts	
Checking	
Institution #1	(k. j. 31)
Account #	g/ (a)
Institution #2	
Account #	
Savings	
Institution #1	

138 MY LAST WISHES

Account # ____

Account #

Institution #2

Miscellaneous

Do you have any POD (payable on death) accounts set up? [N] [Y] In whose name?	
Where:	acct #
Investments	
Institution #1	And the second s
Account #	
	en e
Account #	No. of Section 1
Institution #3	
401K	
Account info	
Other	
	A TALLEY
	The state of the s

Pensions

EMPLOYER	YEARS WORKED	JOB TITLE
#1		
notes		
#2		
notes	网络马克森斯特拉拉克 斯	

notes	The Water and good of the said
Property Owned	
Location	0. 344 344
Notes:	
Location	
Notes:	¥ 38-200
	Line Change Sound
Insurance	
Employer Plan	
Company	The Reserved
Amount	
Beneficiary	2008
Individual Policies	104 (11.2)
Policy #1	
Company	
Amount	

140 MY LAST WISHES

Beneficiary	- 50
Contact information	icalimiză)
Policy #2	
Company	
Amount	Later Trans
Beneficiary	(Agravanni)
Contact information	
Miscellaneous	
Auto insurance policy with	
Health insurance with	
Disability/long-term care policy with	a part
Homeowner policy with	4 4 4
Other	* * * * * * * * * * * * * * * * * * *
$egin{array}{cccccccccccccccccccccccccccccccccccc$	
House	
Mortgage with	
Account #	elfilo (Galenti)
Contact	
Other	

Account # Other Credit Cards Company #1 Account # 800# for company (located on card or statement) Company #2 Account # 800# Company #3	Car
Credit Cards Company #1 Account # 800# for company (located on card or statement) Company #2 Account # 800# Company #3 Account # Boo# Do you have credit card insurance on any of these or other	Institution
Credit Cards Company #1 Account # 800# for company (located on card or statement) Company #2 Account # 800# Company #3 Account # Boo# Do you have credit card insurance on any of these or other	Account #
Company #1	
Company #1	
Account #	Credit Cards
800# for company (located on card or statement) Company #2 Account # 800# Company #3 Account # Boo# Do you have credit card insurance on any of these or other	Company #1
Company #2	Account #
Account #	800# for company (located on card or statement)
Account #	Company #2
Company #3 Account # 800# Do you have credit card insurance on any of these or other	
Account #	800#
800# Do you have credit card insurance on any of these or other	Company #3
Do you have credit card insurance on any of these or other	Account #
가능하면 하는 사람들은 가장이라고 않았다면 보고 있다. 그리고 하는데 경기를 하는데 가장 가장 하는데 하는데 이 사람이 되었다면 하는데	800#
	당했게 하는 사람들이 가셨다고 하셨다. 어린 사람들은 사회의 살림을 하게 하는데 가을 내려왔다. 그 사람들은 아이는 사람들은 사람들이 아니라 살았다. 아이는 아이를 다 먹었다. 그 사고는
Do any of these cards have transferable benefits (i.e., frequent flyer miles, gift points, etc.)?	그 사람이 그는 그는 하는 것이 그 사람이 그 사람이 그 사람들이 되었다.

CONTRACTOR BANKS AND THE	า รับเดิม รายเกิด ร้างจะสีของเดิมแผนเนอง (มีเรี
Loans	
Institution #1	owned tratal distribution a war
Account #	
Institution #2	
Account #	
Institution #3	
Account #	ast that at more
Personal	
Any individuals to whom you owe t	a debt?
Name	The state of the s
Amount of original loan	dated
Any documentation? Where?	
Name	
Amount of original loan	dated
Any documentation? Where?	

Loaned Out Any monies you are owed that can be recouped to your estate? Amount of original loan ______ dated Any documentation? Where? Do you want this loan forgiven [] or collected and added to your estate []? Amount of original loan _____ dated Any documentation? Where? Do you want this loan forgiven [] or collected and added to your estate []? Miscellaneous Safety-deposit box Institution _____location ____ Account # _____ Key located Safe Where? _____combo/key ____

Alarm
Code
Hidden treasure
Any secret stashes inside the house (or in secret locations)? [N] [Y]
Where?
Who would you like to retrieve and keep it?
Journal Entry
Do you keep a diary or journal? [N] [Y] Where is it kept?
What would you like done with it (trash or published?)
Can anyone read it? [N] [Y] Who?
Unmentionables
Where do you keep your naughty things?
Who would you like to remove them?

Passwords

Is it okay for people to search	your computer? [N] [Y]
Your e-mail address:	password:
Second e-mail address:	password:
Password	for what?
Note:	
Password	for what?
Password	for what?
Note:	Alexandra year and and
Keys	
Where are the extra house key	78?
Car keys?	
Any other locked locations? _	
	<u>VI 144 Milionegovino</u>
Doc	cuments
Location	
Birth Certificate	i sidi ayan makan aktaca ak sayar.
Marriage License	ody months of the efficiency.

Social Security Card	
Passport	
Military Records	Seamon Doctor
Bank Statements	- deference
Stock & Bond Certificates	5.11A.00
Tax Records	187 1061
Car Title	Salaman Salaman P
Mortgage Files/Deed	The Condition
Others might include: Adoption papers,	divorce papers, prenuptial
agreement, etc.	
Other	
Other	1110×110×11000000000000000000000000000
Other	
Other	100 to 10
Other	100-80
OtherNotes:	100000 ALIO ALIO ALIO ALIO ALIO ALIO
OtherNotes:	100000 04152 2 ASC 100410
OtherNotes:	100000 ALIO ALIO ALIO ALIO ALIO ALIO

(Will, medical documents, and funeral arrangement paperwork can be found in Chapters 4 & 7.)

Numbers to Know

Primary Doctor	##
Specialist	#
Specialist	#
Dentist	##
Therapist	##
Religious Leader	##
Attorney	#
Investment Broker	# <u>************************************</u>
Accountant	##
Insurance Agent	##
Other	#
Other	##
Other	##
Other	##
	#
Other	##
Notes:	

Organizational Tips

File It. Call me old-fashioned, but with some manila folders and a Sharpie, I'm all set. Label each folder with its contents (i.e., bank statements, phone bills, advance directive, etc.) and add the newest statement/information in front. Or you can sort things in labeled boxes (i.e., all warranties, all tax returns, etc.).

• It's a good idea to put any important papers that your family will need in case of emergency (advance directives, will, etc.) in a red folder that can be easily located.

Safe It. A small safe or locked box works well for private papers. Best to get one that's fireproof and keep it in a hidden location (tell at least your executor where it is). Keep originals (except medical powers of attorney and living will) in the box and copies of each in your files (note on top of copy where original is located). A safety-deposit box at your bank might be preferable if you have non-replaceable items that do not need to be regularly accessed.

Index It. Take a few packs of colored index cards and use them to keep track of various household information. Assign each category a different color (i.e., care of cat, children's medications, number for lawn service, how to fill water softener). Not only is this helpful for when you're gone, but you can use this system to leave information if someone is house-sitting or baby-sitting (just pull that category's cards out and your sitter has all the info they need).

3-Ring Binder It. If you don't share my love of index cards to organize your household management system, how about binders? Whatever method you choose is great as long as all the relevant information can be found in one place.

Label It. Keys need to be labeled. There is nothing more frustrating than a bunch of unidentified keys. If you don't have an identifying tag for each, get some small coin envelopes and write what each key is for on the outside of the envelope.

Note: This chapter is only helpful if you tell someone that it contains the vital information they'll need once your gone.

known?	
Notes	

Is there any other important information that will need to be

		<i>C</i>
		1 100
and the state of the second section of the second section is the second section of the second section of the second section is the second section of the second section of the second section of the second section is the second section of the section of the second section of the section		

CHAPTER TEN

YOU GET THE LAST WORD!

ravo! I applaud your courage to get this far in the journey of exploring your last wishes. You are now among a very small, and may I say brilliant, group of people who care enough about themselves and their loved ones to consider how they want to live in and exit this life. But wait, there's more. . . . We are about to get into the hardest and most important part of the whole thing . . . expressing our last wishes. Sure, you've pondered it—and thanks to this book you've even jotted down some thoughts—but the crucial (and some find most difficult) part is having the conversation with our loved ones and care providers. Let's face it, there are those of us who love communicating about any subject anytime, and then there are those who would rather have a root canal. I could nauseate you with horrible stories about how someone dropped dead before they could say they loved their son, or how fights about inheritance drove siblings to never speak to each other, but I assume if you've read this far you already understand that. Instead, I've chosen to start you off with some ways that might make this process easier and go more smoothly.

Before beginning, let's presuppose you've thought about the basics of how you want your end of life to go. (Completed previous nine chapters? Check. Okay, move forward.)

cate ye	Now it's time to pinpoint with whom you need to communicate your wishes (list below and don't forget doctors and other caregivers besides your loved ones):						
			- 	0.3			

Okay we're almost there. Now let's just run down a few tips and conversation starters for you:

Timing

Make sure you have someone's undivided attention. Maybe even ask them to set aside a Sunday afternoon to talk about it.

Be proud of yourself and them for being mature enough to get this conversation handled. While trying to be sensitive to another's apprehension, make sure you're direct enough to get your wishes spelled out clearly.

Bring a list of everything you'd like to cover (for your convenience I have assembled a handy-dandy checklist summarizing the topics you might want to chat about

with your family-see p. 158 for the Chat-About Checklist).

Make copies of anything someone would need to have copies of. It might help to give them a folder or large envelope with the information so they can follow along (medical power of attorney, living will, etc.).

Don't think one conversation will do it. If your life or health changes and you have some new thoughts about your end of life, try to naturally broach the subject with loved ones.

Talking

Tongue-tied? Don't know exactly what to say? Feel free to incorporate any of the following starters:

So and so at our club (church, office, on our street pick one) just lost their spouse and it made me think we should really get our affairs in order. How about we spend next Sunday doing that and then treat ourselves to a nice dinner afterward?

I recently read an article (saw a program, heard about a seminar . . .) regarding end-of-life planning, and I was wondering if you and Dad have ever thought about it for vourselves?

Your mother and I have decided on how we want things to be handled in regards to life support should a decision need to be made. We want you kids to be clear on our wishes, so we're going to have a discussion about it during next week's family dinner. Be there or I can't ensure your sisters won't get your share of the inheritance!

I'm planning on changing doctors (insurance policy, beneficiary for life insurance . . .) so we might as well fill out those advance directives and wills we've been meaning to get to.

Look I just bought 10 copies of this wonderful book, *My Last Wishes*..., for our whole family and here's your copy to fill out. I think if we all do it together as a family it will really help us address the subject with Mom and Dad.

I read about (saw, know, dated . . .) this fabulous woman Joy Meredith. She seems very bright and I think we should follow her advice and finish our estate planning and advance directives right away.

Yes, I know this makes you uncomfortable, but we need to talk about this stuff or who knows what could happen. Do you really want to take a chance that the kids will have to go live with your brother Bob?

You're not looking so good . . . here, hurry up and fill out this book!

Bottom line: You are an adult and this needs to be handled. Taxes, prostate exams, and childbirth aren't much fun either, but we do them, live through them, and then in the end feel better that they're behind us (no pun intended). If you don't make your wishes known, you are leaving behind a bundle of anguish for your family and I know you love them way too much to do that.

Okay. So now *you're* sold, but let's say your clan is still not convinced how important it is to have everyone in the family clear on each other's wishes. If that's the case, there are a few last tactics to try:

Lead by Example. Fill out your will and advance directives and hand them to your family. Ask them in return what arrangements they've made. If they haven't made any, drop a subtle hint you'll be checking back with them next month and then keep checking back.

Guilt Them. "So you don't care what happens to our/your children if something happens to you?" Okay, maybe not that harsh—but you can always work in a story about someone who left no last wishes and the chaos that ensued.

Bribe Away. Sex, a meal, visits with the grandkids? What will motivate your spouse, sibling, or parent to take this on? Be creative and do whatever's necessary to get it handled.

Chat-About Checklist

☐ YOUR LIFE: Tell those you love that you love them ~ Share what's important to you ~ Impart wisdom from lessons learned ~ Give out thank-yous UNFINISHED: Revisit regrets: Clear your conscience with confessions ~ Offer apologies ~ Allow forgiveness of others ~ Plan and live your dreams ☐ THOUGHTS ON DEATH: Ponder your beliefs in an afterlife ~ Reflect on your religious/spiritual philosophy ~ Discuss any concerns about death/dying LEGAL ISSUES: Create your will/trust ~ Put in place a living will and/or powers of attorney ~ Name executor & proxy and review your wishes □ MEDICAL WISHES: Discuss and put in writing thoughts on: life support/DNR directives ~ Organ donation ~ Autopsy ~ Give copies of AMDs to family and doctors □ LAST DAYS: Envision: Where are you? Who's near? What surrounds you? ~ Would you like hospice care? ~ Who should your loved ones notify at the end? SERVICE: Plan: Which would you prefer, burial or cremation? ~ What sort of service/ memorial? ~ Have arrangements been made? ~ Any extra touches? □ LOVED ONES & STUFF: Establish guardians for your kids (and pets) ~ Consider granting a blessing to remarry ~ Who do you want to inherit your money & stuff? ☐ **INFORMATION:** List your vital stats ~ Where are the important papers? ~ Who are the need-to-know people? ~ Where are the keys/any other pertinent items? ☐ <u>LASTLY</u>: Leave some love behind ~ How do you want to be remembered? ~ What do you want your legacy to be? ~ Convey any last wishes . . .

Now note: Who have you discussed your end-of-life issues with?

WHO	WHAT (TOPIC)	WHEN
notes		
notes		
noces		
notes		
notes	kaji, je sa um tan je salutisan	atan bal-1 ya
	and the second of the	
notes		
notes	reconstruction and the second	run randania
Tiotes		
notes		
notes	ke modesiza o sakori	osci ve qualific
	en alle de la companya de la company	
notes		
notes		22.000 (A.A.)
Tiotes		
notes		
notes		
notes		

WHO	WHAT (TOPIC)	WHEN
notes		
notes		
notes		1 12 4

Love, Truths, and Video

If only I had captured his infamous "Duke" joke . . . When someone we love dies it's not always the things we think we'll miss that hit us. We know we'll miss the way our loved ones laughed, and smiled, and made us feel . . . but sometimes it's the weird things we wish we had frozen in time. For me, I miss never hearing the "Duke" joke again—at least not the same way Ted told it. Well, it's hard to capture smell, and we can never re-create their touch, but by golly with today's modern technology we can preserve a joke about a farting dog (Duke) for posterity!

It seems silly not to take advantage of the times we live in and use video and audio to capture the thoughts, wishes, and merriment we want to leave behind for our loved ones to remember us by. Besides the jokes, stories, and laughing, we can also use recording capabilities to handle even more seemingly important subjects as well—like your wishes about life support and your good-bye messages to your loved ones. I recommend capturing three important categories on video: your life support wishes, your house contents, and your love notes to your loved ones. Let's take a quick look at each. . . .

Life Support

You have written your living will and/or appointed someone as your proxy, but if you are at all concerned that there might be a dispute or you want to make sure your proxy has a clear indication of your wishes, leave a video spelling them out.

Your Things

It's not only a good idea for you to video what you want people to have so there are few disputes, but this also serves as a big help if you need to make an insurance claim when disaster strikes. Walk through your home (try to be organized and not ramble) and identify what your prized possessions are and to whom you are leaving them.

A Little Love

To hear a laugh, see a smile, capture their essence . . . it's all priceless when someone passes. Oftentimes, if you are not a camcorder family, you might not have these precious moments and memories captured on video. Many times a message left on voicemail is the only voice memento of a loved one—so sad. Now is your chance to leave a message to your loved ones so they have something of you to treasure. It doesn't matter if you think you have 70 years left to live; everyone would love a message telling them how much they are loved. (These are also great to have around when you need a reminder—or the bad days when you forget—why you married your spouse!)

A Tender Tape Tale . . .

Erin Kramp was in her early thirties when she knew she might not survive her bout with a life-threatening illness. Instead of being immobilized by fear, she decided she wanted to leave her family (especially her young daughter, Peyton) a legacy so they would be comforted and guided when she was not with them. She spent hours upon hours taping the things she thought a mother should teach and share with her daughter. She left gifts and cards for special occasions in the future. She put together meaningful scrapbooks and the relevant paperwork her loved ones would need. All this and she made time to write a book about it (*Living With the End in Mind*) and make a few TV appearances. Everyone who has seen this remarkable woman's story cannot help but be overwhelmed by her love for her family and her bravery in facing her immortality with such grace.

I mention Erin because even though we all might not be able, or find the need, to take on such a bold and significant project, we can leave at least a little something. Even if it's just once a year, pull out the camcorder and tape some messages just because. Here are some taping tips:

- If you don't own a camcorder, most phones can take great quality video that can be stored and sent digitally.
- Videotaped wills or other estate decisions are not legal. This is not instead of, but in addition to. You must have your wishes in writing for them to be legal.
- Use video (or even audio) to capture your favorite stories, jokes, singing, or tales of family history.
- If you can't figure out how to set the camcorder's time/date stamp (it is in the manual, just so you know),

then hold up today's paper and look into the camera and point out the date.

Men: a video love letter might serve as a great lastminute Valentine's Day gift. Kills two birds with one tape: keeps you from getting killed in the first place and takes care of leaving some love.

Make it a group project to interview the family (especially grandparents) about their lives. I promise not only is it great for legacy purposes, but it will lead to interesting conversations and discoveries along the way.

Tapes disintegrate with time. To preserve memories more permanently, have them put on a DVD or other digital format.

In the END ...

We don't get to control all that much in life, so we might as well have a thing or two to say about our end of life. Trust me, even if you need to prompt them a little, your family wants to know how your life is going, what's important to you, and how (if possible) you want your end of life to play out.

So think about it, organize yourself, and then make sure you get the last word!

FINAL NOTES				
Salating France	er en sen	20100	SECTION S	
sago dilw skut om				
OBLIGATION OF THE STREET			2. 17. 20. 54 . 3965 - 313 8469765360	
eret elignification acces				
serve semong i swil				
02 DESI (1889)				
the Afthorn spring A				
Zolonium vetoro (
			and the best of the	
			1 1 1 1 1 1 1 1 1 1 1 1 1 1 1 1 1 1 1 1	
drocas traina iwani, i	116 (1200)	eda balero	2000年第二百岁	a V
mayo lamidan atting				
would be have the service of the ser			negrapionalizada po Tempo (Michaelego)	
			terrames nerd	
And a second of the second of	72440	24611.810	The state of the s	Sec.

MY LAST WISHES . . . FOR YOU

I deeply miss the ones who I have loved and lost to death.

My peace comes in the fact they each knew that I loved them; and that is all I can wish for you.

Tell the people in your life how much you love them . . . even at this very minute I bet they're dying to know!

—Joy Meredith

MY LAST WISHES AND YES

RESOURCES

Aging with Dignity (*Five Wishes*—document) www.agingwithdignity.org; 1-888-594-7437

National Hospice and Palliative Care Organization www.nhpco.org or www.caringinfo.org; 1-800-658-8898

American Hospital Association www.putitinwriting.org

AARP

www.aarp.org; 1-888-687-2277

American Bar Association www.abanet.org; 1-800-285-2221

Celebrant USA Foundation www.celebrantinstitute.org; 973-746-1792

Department of Veterans Affairs www.cem.va.gov; 1-800-827-1000

Federal Trade Commission www.ftc.gov; 1-877-382-4357

Organ Donation

www.organdonor.gov

This is the U.S. Government's official website regarding organ and tissue donations.

BOOKS

Death and Dying

Being Mortal: Medicine and What Matters in the End. Atul Gawande. (Metropolitan Books, 2014)

The Best Care Possible. Ira Byock, M.D. (Avery, 2013)

The Conversation: A Revolutionary Plan for End-of-Life Care. Angelo Volandes. (Bloomsburg USA, 2015)

Dying Well: Peace and Possibilities at the End of Life. Ira Byock, M.D. (Riverhead Books, 1998)

Final Gifts: Understanding the Special Awareness, Needs and Communications of the Dying. Maggie Callanan and Patricia Kelley. (Simon & Schuster, reprint 2012)

How We Die: Reflections on Life's Final Chapter. Sherwin B. Nuland. (Vintage, 1995)

The Needs of the Dying. David Kessler. (HarperCollins, 2007)

On Death and Dying. Elizabeth Kubler-Ross, M.D. (Scribner, reprint 2014)

Remember Me. A Lively Tour of the New American Way of Death. Lisa Takeuchi Cullen. (HarperBusiness, reprint 2007)

Talking About Death. Virginia Morris. (Algonquin Books, 2004)

The Tibetan Book of Living and Dying. Sogyal Rinpoche. (Harper SanFrancisco, revised 2012)

Estate Planning

- AARP Crash Course in Estate Planning: The Essential Guide to Wills, Trusts, and Your Personal Legacy. Michael T. Palermo. (Sterling Publishing, updated 2008)
- The American Bar Association Guide to Wills & Estates (4th edition). The American Bar Association. (Random House Reference, 2013)
- The Complete Idiot's Guide to Wills & Estates (4th edition). Stephen Maple. (Alpha, 2009)

Estate Planning Basics (7th edition). Denis Clifford. (NOLO, 2013)

Make Your Own Living Trust (11th edition). Denis Clifford. (NOLO, 2013)

Miscellaneous

How to Care for Aging Parents (3rd edition). Virginia Morris. (Workman Publishing Company, 2014)

Man's Search for Meaning. Viktor E. Frankl. (Beacon Press, 2006)

An Open Heart: Practicing Compassion in Everyday Life. The Dalai Lama (edited by Nicholas Vreeland). (Back Bay Books, reprint 2002)

A Short Guide to a Happy Life. Anna Quindlen. (Random House, 2000)

Note: Above are some of the resources used while researching the book or that I've recently found valuable. I'll be updating new resources at joymeredith.com.

ACKNOWLEDGMENTS

It took me a year to research, conduct interviews, and write this book. When it first came out, my mother was so happy and proud she would introduce me around to her friends and clients: *Have you met my daughter, the authoress?* Most of the time it was pretty embarrassing, not to mention I had already done some semi-decent things in my life. But having a book published was her favorite of my accomplishments. And now that she's gone I would so much love to hear those words again.

The discussions we had around *MLW* would make the decisions I ended up having to make in her final days so very clear. There was no arguing with my siblings, no big debating any of the choices, no confusion—it made a horrible time bearable. She gifted me with life . . . and then the strength to be able to see her through the end of hers.

Thank you to my family for the love, fun, roadtrips, and lake time. With you, life is good!

To my extraordinary agent, Laurie Abkemeier: I tried repaying

you with your very own VSP, but I'll never be able to truly thank you enough.

Thank you to the fabulous people at HarperCollins and William Morrow. Anne Cole Norman: I was really lucky to get to work with you, and I'm so happy you have gone on to create a big happy tale of your own. Trish Daly: Thanks for giving *MLW* new life—I could not be more thrilled.

And to Phil Friedman: Thanks again!

To those I am fortunate enough to have make my life so joyful: Vickie Austin (MBF ©), Shelly Colla, Colleen Fahey, Jennifer & Rick Smith, Dana Campbell, Diane Krause, Michelle LaLond, Joy Ryba, Mary Doranski, Lynn LaPlante Allaway, Kim Kreft, Laura Broucek, Jenny Luzzo, Karyn Denten, Suzanne Casey, Heidi Picard, Peggy De La Cruz, Jim Michelsen, my A-Phi sisters, Ron & Barb Moretti, Helen & Tom Kuhl, Christine Oberg, Judy Offner, and Aunt Christine and Uncle Bill Garrity . . . thank you for your love and friendship.

Last, I believe that each person who touches your life makes you who you are, and I appreciate everyone who has contributed to, and allowed me to appreciate, mine. With warm thoughts and in loving remembrance of Ted Petkus, Christopher Day, and Melba Nannini. I hope to honor your memories by living a wonderful life filled with love and laughter.

ABOUT THE AUTHOR

Julie Mar

JOY MEREDITH is an expert on appreciating life and discussing death. After losing several of the people she has loved, Joy knows firsthand what it is like to be left without any instructions for carrying out a loved one's final wishes. A writer, consultant, and the creator of ME Mapping, she lives and leads workshops in the Chicagoland area.

HOUTUA HTUDU

CPSIA information can be obtained at www.ICGtesting.com Printed in the USA LVHW040823071119 636597LV00009B/60/P